calligraphy a guide to hand-lettering

margaret morgan

photography by john freeman

First published in North America in 2001 by North Light Books an imprint of F&W Publications, Inc. 1507 Dana Avenue Cincinnati, OH 45207 1-800/289-0963

Originally published in the UK in 2001 by New Holland Publishers (UK) Ltd

All rights reserved. No part of this book may be reproduced in any form or by any electronic or mechanical means including information storage and retrieval systems without permission in writing from the publisher, except by a reviewer, who may quote brief passages in a review.

Text and calligraphy designs copyright © 2001 Margaret Morgan Photography copyright © 2001 New Holland Publishers (UK) Ltd Copyright © 2001 New Holland Publishers (UK) Ltd

ISBN 1-58180-218-8

Editor: Clare Johnson

Design and Art Direction: Blackjacks

Photographer: John Freeman

Editorial Direction: Rosemary Wilkinson

Reproduction by Modern Age Repro House Ltd, Hong Kong Printed and bound in Singapore by Tien Wah Press (Pte) Ltd

Every effort has been made to present clear and accurate instructions. Therefore, the author and publishers can offer no guarantee or accept any liability for any injury, illness or damage which may inadvertently be caused to the user while following these instructions.

ACKNOWLEDGEMENTS

Grateful thanks to the following for providing the materials for photography:

Daler Rowney Ltd, Winsor & Newton, L Cornelissen & Son Ltd, Falkiner Fine Papers, Cowling & Wilcox.

Thanks also to friends and calligraphic colleagues who have guided and encouraged me over the years, especially my patient and understanding husband.

contents

Introduction A brief history of Western calligraphy An equipment overview Setting up your studio The specifics Paper Making your mark	4 6 8 12 13 16 19		
Roman capitals Foundation hand Italics Versals	24 26 28 30		
Practice projects Alphabet broadsheet Words as patterns	32 33 34	4	
Design skills		36	
Combining	h monogram	40 41 44 48 52 56	ó .
Pushing	g out the boundaries		60
Gilo Al	stmas card ded and decorated letter phabet and gilded A–Z A magic carpet: gilding w	vith color	65 68 72 76
	Glossary Useful addresses/Bibli Index	iography	78 79 80

introo

Lettering is fun! This book is intended for beginners or those with just a little experience of wielding a pen. It aims to give you the information you need to write several different scripts well, and goes on to introduce the use of design in simple calligraphic projects. Once you have grasped the basic skills of good letterforms, there are so many exciting techniques and materials, both ancient and modern, to try out for yourself.

In this age when computers seem to be taking over so many things, it does no harm at all to re-examine the source of the letters we see and use every day. Look at how those 26 letters are made following traditional models, then take courage and go forward with experiments of your own. Try to be open to ideas from other cultures too; other less familiar influences than your own can inform your thinking and open up new horizons.

My involvement with calligraphy started early; learning how to do italic handwriting aged eight and a gift of some broad-edged nibs had me hooked. I studied graphic design at college, specializing in typography – letters again – and this formed the major part of my work for over ten years. The art training was certainly useful for extending the creative possibilities for the many gifts I have made over the years using letters. Those edged pens were never far away and calligraphy has now taken over completely from graphics, which gives me much satisfaction.

Calligraphy – A Guide to Hand-lettering gives you a glimpse of what is possible with pen, paper, inks and paints, given a little time and enthusiasm. You may find, as I have, that your interest goes way beyond the hobby stage, and is with you forever.

Margaret Morgan

Monday Lundí Montag Lunedi Lunes	Tuesday Mardí Dienstag Martedí Martes	Wednesday Mercredí Míttwoch Mercoledí Micrcolès	Thursday Jeudí Donnerstag Gíovedí Jueves	Friday Vendredí Freitag Venerdí Vicrnes	Saturday Samedi Samstag Sabato Sàbado	Sunday Dímanche Sonntag Domenica Domingo
	1	2	3	4	5	6
7	8.	9	10	11	12	13
14	15	16	17	18	19	20
21	22	23	24	25	26	27
28	29	30	31			

JANUARY JANUARI ENERO GENVAIO

a brief history of western calligraphy

The history of calligraphy, like many other histories, is cyclical: a new writing style is born, developed and eventually dies or goes out of fashion; this is followed by rediscovery, reappraisal and further improvement. What follows is only an outline of how our current letterforms came into being.

roman capitals

Our familiar Western letterforms mostly stem from the Roman capitals (or majuscules) of the early centuries AD. These capitals were used for important and formal inscriptions. It is generally believed that the letters were first painted with a square-edged brush, then cut into a V-section in stone. The pattern of thick and thin strokes shows the calligraphic influence of the tools used to make them and

the angle at which the tools were held. They weren't "everyday" letterforms though, as they required care and precision in the making.

Square and rustic capitals fall into the same category. These early book hands were used for writing out classical

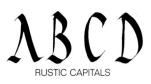

texts. They were slow to write and required much pen manipulation to achieve the shapes – not natural pen-written forms at all.

Scribes gradually modified the capitals to economize on effort for the sake of speed; they took notes with their

SOUARE CAPITALS

metal styli onto wax tablets and gradually a cursive or running hand evolved. These tablets could be smoothed over and reused after the text had been transferred to a more permanent form, such as with reeds or quills on papyrus.

uncials and half uncials

Between the 4th and 8th centuries AD, uncials developed out of the old Roman cursive hand, for writing out Christian

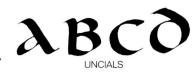

texts. The forms were rounded, written with a slanted pen at a shallow angle and showed the first real suggestion of ascenders and descenders. These are the first true pen-made letters, the shapes being created by the nature of the tool, not by trying to imitate anything else. They are clear, simple and legible, and continue to provide inspiration to modern calligraphers. Later forms were written

with a flat pen angle.

The spread of Christianity had much to do with the next

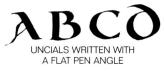

development of written forms. The Roman Empire began to decline into chaos, incessant wars caused further difficulties and much "pagan" classical literature was lost during the period we call the Dark Ages (AD 550-750). Cultural life in Europe more or less ceased as the barbarians invaded and care of books and teaching passed to the care of the church. Half uncials developed independently during this time in Ireland and England from early examples of Roman uncials, and show clear ascenders and descenders. The most famous examples of the different types of

Lindisfarne Gospels.

"insular" half uncials can be seen in the Irish Book of Kells and the English

carolingian minuscules

The Age of Charlemagne was another important milestone. The Emperor Charlemagne was passionate about books and learning. His ambition was the revival

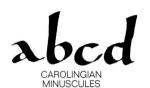

of cultural life, for which books were essential. In AD 789 he decreed that all liturgical books should be revised. The Carolingian hand is characterized by a clear fluency and legibility which was ideal for these book texts. It was combined with the majuscules (built-up Roman letters, rustic capitals and unicals) of antiquity which were used for chapter headings, sub-headings and the beginnings of

abcd

verses, the hierarchy of scripts scribes still use today.

An English version of this hand was developed as an almost perfect model for

formal writing – strong forms, logically made with a consistent pen angle and easily read.

gothic

By the 12th century letterforms were becoming more and more compressed and the soft flow of Carolingian gradually gave

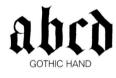

way to the heavy, angular black letters of northern Europe known as Gothic. Materials became more expensive as demand for books increased, so the need to economize was greatly helped by the narrow Gothic letters that took up a lot less space, but which were harder to read.

There were regional variations of the style across the European continent; the northern European quadrata had diamond feet and was very angular; rotunda, used in Spain

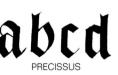

and Italy, was much rounder in form; and the precissus Gothic of English manuscripts was characterized by its flat feet.

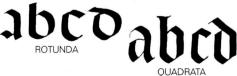

the renaissance

During the Renaissance period in Italy (c.1300–1500), there was a resurgence of interest in classical literature and Italian scribes rediscovered

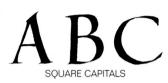

the Carolingian minuscule. They also studied the Roman inscriptional letters and Bartolommeo San Vito revived the use of square capitals, developing his own distinctive

abc

style. Humanist minuscules, closely based on Carolingian, with their rounded forms were very legible, dignified and perfectly suited to formal texts.

What we now call italics also emerged at this time. Written with a slight slant and fewer pen lifts, italics were oval in form and flowed elegantly and relatively swiftly from the pen, making them ideal for secretaries writing documents at speed. Italics eventually evolved into

and thins are made by applying degrees of pressure to a pointed nib, a move away from true pen-written forms.

modern calligraphy

copperplate script, where thicks

Printing with movable type was invented around the mid-15th century, but printing didn't entirely destroy the art of penmanship. Letters patent and diplomas were still produced in the traditional way. However, much of the craft fell out of use for almost two centuries, until William Morris rekindled interest in pen-lettering for the Arts and Crafts movement in the 19th-century. Morris championed the cause of the craftsman-made object in an age of increasing mass production, putting his studies of old manuscripts to good use when he set up his Kelmscott Press in 1890, in order to print beautiful and individual books. The real breakthrough for calligraphy came with the researches of Edward Johnston during the early part of the 20th century. His painstaking work brought about the rediscovery of broad-edged nibs and their importance in the development of the Western alphabet. His influence spread throughout Britain and into Europe in the 1940s and 50s, as well as to the United States.

an equipment view

The very basic requirements for creating letterforms are pen, pencil, ink, paper and a drawing board, but before long you will probably want to add other items to your toolbox, such as some of those listed in the following pages, in order to complete the projects in this book. Buy these extra items gradually, getting the best you can afford, which will pay dividends over time. Good equipment not only gives satisfaction in use, but, as long as it is properly looked after, will last for many years.

essential equipment

To start practicing calligraphy you will need just a small toolbox of essential equipment.

BRUSHES: Load nibs and mix paints with inexpensive brushes and keep the best quality sables for fine finished work (see page 15).

DIP PENS: A dip pen consists of a pen holder that can be fixed with nibs of various sizes and ink reservoirs, if required (see pages 13 and 19). It can be used with ink or paint (see page 13).

DRAWING BOARD: You will need a board at least A2 size (420 x 594 mm/16 x 23 in), preferably larger, to work on. Instead of buying a board, you can easily make your own, quite cheaply, from a scrap of medium density fiberboard (MDF) (see page 12).

INK: Use non-waterproof ink bought in bottles (see page 14).

MASKING TAPE: A low-tack masking tape should be used to attach paper to the drawing board surface; it can be removed easily.

METAL RULER OR STRAIGHT EDGE: This should be used for cutting paper or card with a scalpel or craft knife; a plastic ruler will be quickly damaged by sharp scalpel blades.

PAPER: You will need a variety of papers, depending on the nature of the project, as well as layout and tracing paper to make roughs (see page 18).

PENCILS: Have an H or HB handy for ruling lines (see page 15).

PLASTIC ERASER: This should be soft enough not to smudge or spoil lettering.

TRANSPARENT RULER: A 45 cm (18 in) clear plastic ruler will be the most useful for ruling lines because you can see your work through it.

useful additions

These additions to the basic toolbox will be necessary as you progress from the early writing exercises to working on the projects.

BONE FOLDER: This specialist tool is used for scoring and folding paper and is available from suppliers of bookbinding materials.

COMPASSES AND DIVIDERS: You will need these to draw circles and mark points for ruling lines. Springbow dividers have a central screw to retain a set measurement.

CUTTING MAT: This is a special mat made from "self-healing" rubber that does not blunt or damage scalpel or craft knife blades. Thick card is a cheaper, temporary alternative.

KNIFE: A scalpel with disposable blades should be used for trimming out finished work. A pointed blade is best for this, but scalpels have different blades for different applications. Use a craft or Stanley knife for heavy card, as the stronger blades will withstand the extra pressure required without snapping. Both knives are useful for sharpening your pencils to a really sharp point.

PAINT: Designer's gouache is the most commonly used paint for writing with a dip pen. Watercolor paints are used to make background washes (see page 15).

PALETTE: A palette with a number of small wells can be used for mixing paint. A lidded palette will stop paints drying out.

REPOSITIONABLE GLUE: Rubber cement is a non-permanent glue that is useful for making paste-up layouts since it can be repositioned. Glue sticks and glue tapes are also available with repositionable adhesive.

RULING PEN: This pen can be used to rule neat, straight lines in ink or paint. It can also be used to write with.

SCISSORS: Good, sharp scissors are an alternative to a scalpel for paste-ups, but they won't give an accurate enough line for trimming out finished work.

SET SQUARE: Get an adjustable one if possible – it helps with checking pen angles and ruling lines easily at different angles as well as the normal, right-angle lines.

T-SQUARE: Using one of these makes ruling up writing lines much easier as it hooks over the left-hand edge of the drawing board, allowing you to make an accurate horizontal line.

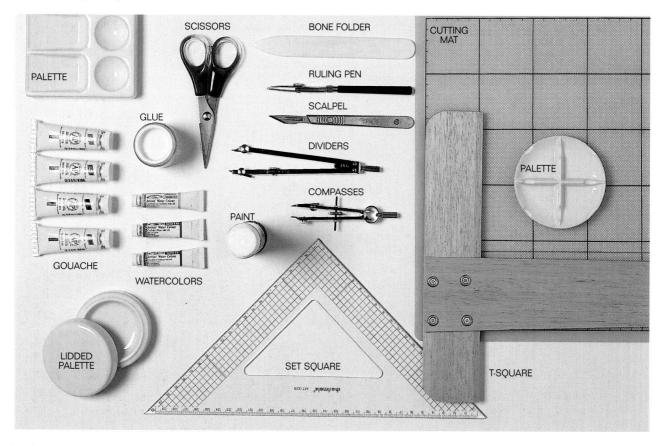

specialist extras

The following tools and materials are needed for specific tasks or processes. Some of these items are available only from specialist shops (see page 79).

ARKANSAS STONE: Used for sharpening nibs (see page 14). A cheaper alternative would be to use 400-grade wet-and-dry paper.

CHINESE INK STICK AND INK STONE:

The ink stick is ground into a little distilled water on the ink stone to make your own ink (see pages 14–15).

GUM AMMONIAC: This plant resin is soaked in water to make a size (glue) for gold leaf. It is also available as a readymade solution.

GUM ARABIC: This substance helps paint flow when the paper surface is slightly shiny or greasy. It can be bought as a ready-made solution or as crystals to be crushed or dissolved in distilled water.

GUM SANDARACH: In ground form, this material can be dusted over the surface of greasy papers to achieve a crisper line.

MASKING FLUID: A rubber solution that can be applied with a pen or brush (synthetic) as a resist fluid, repelling paint or ink laid over the top of it.

OX GALL LIQUID: Like gum arabic, this substance aids the paint flow from a pen or brush.

POUNCE: This fine powder is used to remove grease from the paper surface.

PVA GLUE: A permanent adhesive that dries clear. Buy an acid-free variety to avoid long-term damage to paper. Mixed with water it makes a gesso for gilding. Can also be used as a varnish.

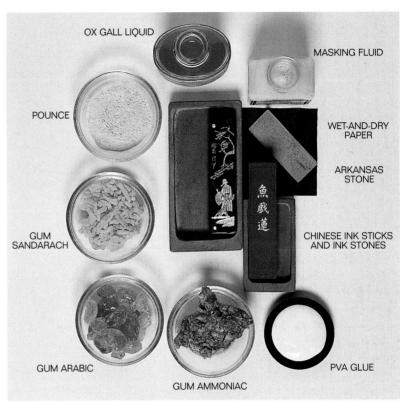

looking after your materials

Taking care of your tools in the following ways will ensure that they continue to produce great results.

Rinse and wipe nibs and reservoirs during and after use, to stop them getting clogged with ink. Agitate the pen to loosen the ink, then dry off the nib and reservoir on a paper towel, but avoid catching loose fibers in the nib tines. Change the water from time to time.

Always wash brushes out thoroughly after use. Rinse first under running warm water, then rub it over a cake of soap and lather gently to loosen any paint or ink. Rinse again in warm water, repeating the soap and rinse stages until the water runs clear. Dry carefully on a paper towel and repoint the bristles. If any hairs stick out, another touch on the soap will help them back in place.

Replace caps and lids on containers to stop evaporation and spillage. A pad of masking tape on the bottom of the bottle is a good way to prevent accidents.

Save your blades by pushing them into a cork or piece of eraser when not in use.

setting up your

The set-up of your studio or workspace is essential to your comfort and health, but for the beginner this task need not be expensive or time-consuming. There are just a few basic points to remember.

Commercially made drawing boards are quite expensive, but a sheet of plywood or MDF, 5 mm (about $\frac{1}{4}$ in) thick with the edges sanded smooth makes a good substitute. This can be propped up at an angle against a table and rested on your knee. The angle will depend on how comfortable it is for you and on the work you are doing. Diagrams (A) and (B) show ways of maintaining the board angle.

Pad your board with several sheets of blotting paper or newspaper under a sheet of cartridge paper, secured with masking tape. This will give a more responsive base than the hard board.

You will need a guard sheet of clean, plain paper taped over the bottom half of the board, to protect your work from greasy hands and spills. It keeps the work in place, but allows you to move it easily as necessary.

Slit a cardboard tube lengthways and slip it over the edge of the board to prevent large sheets of paper getting creased. Secure with masking tape.

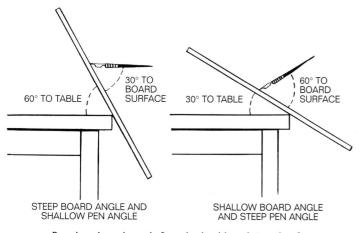

Board angle and penshaft angle should work together for best ink flow. Experiment to find what works best for you.

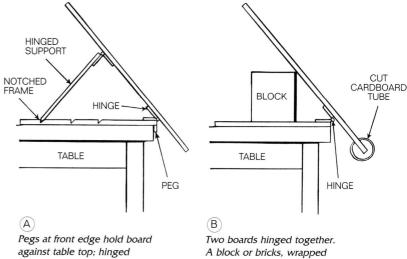

supports fit into notched base to maintain angle.

in cloth to prevent slipping, retain the board angle.

are you sitting comfortably?

Set your board up in an area with good light to avoid eye strain. Daylight is best, with a north-facing window giving the most even light. If this is not possible, use an adjustable anglepoise lamp with a "blue" bulb, which imitates daylight. Light should come from the left if you are right-handed and vice versa for left-handers. Aim to avoid shadows over the working area, which is important when you are mixing and matching colors.

Make sure the table is large enough to give you room on either side of the board to lay out your pens and other materials.

The chair should support your back and help to keep you sitting up straight. At all costs resist the temptation to lean forwards as you work, this will soon cause back and neck pains. A height adjustable chair is the ideal solution.

the specifics

Most of the materials mentioned here should be available in large art shops. The more obscure items, such as ink sticks and stones, tend to be stocked by specialist retailers, although there are some exceptions. Some of these shops have excellent mail order services, or online shopping facilities. See the stockists and suppliers list on page 79 for more information.

pens

Quills or reeds were the earliest writing tools, but these need special preparation and skilled cutting, so most calligraphers now use metal nibs, which are widely available. Dip pens are the most widely used, and can be fitted with a variety of different shaped nibs, and used with ink or paint.

NIBS FOR DIP PENS: The sort of writing dealt with in this book requires broad-edged nibs. These have writing edges, not points, and make thick and thin strokes naturally without the need for heavy pressure. If you have never used a nib like this before, it may take a little getting used to, but the exercises described later in the book will help you.

Several manufacturers make broad-edged nibs. You are likely to find it easiest to buy nibs as complete sets from the widest (0) to the finest (6) with a pen holder, but they can be obtained singly from specialist suppliers (see page 79). Practically, you need only two or three to begin with, such as a No. $1\frac{1}{2}$ (3 mm/ $\frac{1}{8}$ in), a No. 3 (1.5 mm/ $\frac{1}{16}$ in) and a No. 4 (1 mm/ $\frac{1}{32}$ in), the mid- to larger sizes being slightly easier to control than the fine nibs when you are just beginning.

When buying nibs, scrutinize them carefully. Discard any which are crooked, badly formed or have splayed tines. There are special left-oblique nibs for left-handers. Square-edged nibs are also usable with ink, paint and other writing fluids.

PEN HOLDERS: To use broad-edged nibs, a pen holder which feels comfortable for the size of your hand is essential. They vary from basic round plastic ones which

cost very little, to exquisitely crafted wooden ones at the top of the price range. Once you have found a style you like, buy one pen holder for each nib you are likely to use so that you don't have to keep swapping the nibs around, getting inky fingers in the process.

RESERVOIRS FOR DIP PENS: These are very useful devices for holding a small supply of ink on the nib. I prefer the slip-on type, which go under the nib, as I find the ink flows well with this variety. Reservoirs need to slide on snugly enough not to fall off, but not so tightly that the ink is restricted by the squashed tines. The "wings" of a reservoir can be adjusted relatively easily for a good fit (see page 19). Other types of nibs have an over-nib reservoir that holds the ink supply above the slit between the tines, rather than below it. These can be adjusted by bending them upwards to allow more space for the ink.

FOUNTAIN PENS: Calligraphy fountain pen sets are fairly widely available. They are best suited for normal handwriting or for trying out ideas quickly, rather than for finished work. The main drawbacks are the limited range of nib sizes and the fact that you are restricted to using very thin ink in cartridges, and certainly not paint.

AUTOMATIC PENS: These are used for large-scale work, but they also come in a variety of forms to give many different types of line. Load with a brush and they will write well with ink or paint. Putting several colors into one pen can be fun and produces interesting as well as unexpected effects.

nib sharpening

Most nibs will write perfectly well for some time, but you do need to keep them sharp for consistently crisp writing. Follow this procedure with some caution as it is quite as easy to ruin a nib as it is to improve it. Drop a little distilled water onto a sheet of 400-grade wet-and-dry paper (or a fine-grade Arkansas stone) laid on a flat surface. With the nib upper side to the abrasive surface supported by the middle finger, pull the pen to the right, pushing down gently and evenly with your thumb – don't press too hard. Left-handers should reverse the direction of pull. Repeat this motion two or three times (1).

"Write" a figure of eight in the water a couple of times to remove any burrs of metal (2). Blot the nib dry.

Check that both tines of the nib have been sharpened equally by looking at them through a magnifying lens, then try it out on layout paper with a little ink. Take care not to oversharpen, or the nib corners will cut into the paper. Step 2 helps to avoid this but sharp corners can be touched very gently on the abrasive paper or grind stone.

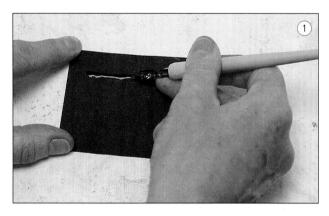

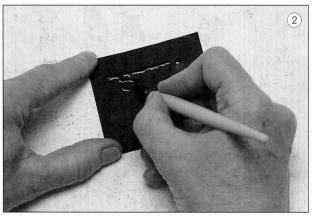

inks

BLACK INKS: Ready-prepared liquid carbon black inks, are the most widely available. Use the non-waterproof kind so that your nibs do not get clogged with the shellac present in waterproof types. The ink should give a fine, clear line and can be thinned with distilled water if necessary. The many different brands vary in composition, so use trial and error to find the one you like best. Ease of flow, density and consistency of color are the important criteria. Remember that ordinary fountain pen inks are too thin for use with dip pens.

COLORED INKS: Use these with discretion. Their colors tend to be rather vivid and acidic, which can be rather hard on the eye, and the consistency of coverage and opacity is patchy, but they might just give the effect you want. Check that they are non-waterproof before you buy. You will also need to be very thorough in cleaning pens and particularly brushes after use. For solid color coverage use gouache paints (see page 15).

CHINESE INK STICK: This is my favorite kind of ink, but it does take a little time to prepare. The ink stick is ground with water on a special stone. Better quality sticks produce blacker inks; those with a matt surface are more reliable for quality than shiny ones.

grinding ink

Choose a large ink stone that gives you room to move the ink stick during grinding. Use an eye dropper to drop a measured quantity of distilled water – following the manufacturer's instructions or using your own recipe – onto the stone and rub the stick on the surface in a rhythmic circular motion (3). Make a note of the quantity of water and grinding time used to enable you to repeat the exercise reliably. I use 10 drops and grind for $2\frac{1}{2}$ minutes.

Test the ink by writing on a scrap of layout paper to check you have the density of black you want. Grind for longer if it is not black enough, or for a shorter time for a paler grey. Transfer the ink to a small screw-top jar. The ink will stay fresh for a little while, but is better ground fresh each time. Stir before use.

Scrub the stone clean and dry the end of the ink stick to stop it cracking.

The stone will eventually be worn smooth by repeated grinding, but you can refresh the dry surface by rubbing it gently with 400- to 600-grade wet-and-dry paper.

pencils

Buy good quality branded pencils, as the cheaper ones tend to have gritty leads and can be difficult to sharpen adequately. Leads are graded according to hardness. H to 9H are hard, B to 9B are soft, the highest numbers being hardest or softest accordingly.

To rule up for writing, an H or HB sharpened to a good fine point with a scalpel will give you accurate lines. Be careful not to press too hard or you will score the paper. The softer pencils are better for drawing than ruling up, as they give wider, blacker lines and blunt more quickly.

paints

GOUACHE: When you want to use color in your work, paint is the best option and the type most frequently used by calligraphers is designer's gouache. It gives the best and most consistent results in coverage and opacity, as well as endless possibilities for mixing different color variations. There is a range of gouache produced specifically for calligraphy, which is very good. On some more absorbent or greasy surfaces, paint will give crisper results than ink, so black gouache is a good standby. Please note that acrylic paints are not suitable for writing with as they dry quickly and will clog your pen.

WATERCOLORS: These paints give a less opaque finish than gouache or ink for writing, but are very useful for doing transparent colorwashes as backgrounds. Artists' quality will give the best results.

brushes

SABLE BRUSHES: The best quality brushes for use with watercolor and gouache paints are made of Russian red sable. The hair is springy and absorbent, holding color well. These top quality brushes are best kept for painting, using a No. 3 or 4 for covering larger areas with flat color. Short-haired brushes (size 000) are perfect for fine details and outlining.

SOFT-HAIRED BRUSHES: These brushes (such as squirrel, ox and goat hair) tend to wear out more quickly and point less reliably than sable. They are perfect, however, for laying washes (large size) or for mixing paint and filling nibs (smaller sizes).

SYNTHETIC BRUSHES: Brushes made with synthetic hair are not as flexible or as sensitive for painting as sable, nor do they hold as much color. They are reasonably priced and are useful in particular with difficult substances – such as PVA glue, gum ammoniac and masking fluid – that may need to be removed with solvents which would ruin sable brushes. Mixed sable and synthetic brushes are a good all-round compromise.

-mixing paint

ix up a generous quantity of paint in a palette using distilled water to reproduce the consistency of single cream. You will need plenty of paint to do all the preliminary work as well as the finished piece. This mixture will write very well in a dip pen and give good coverage in areas of brush-painted color as well.

If the paint dries out in the palette, it is easily reconstituted with a little more water. A lidded palette will keep the colors moist, or you can cover it with transparent food wrap (cling film) instead.

Keep a different brush for loading each color onto the pen, and change your water often so that the mixed colors don't become muddy.

Mix the paint the day before you need it. Any excess glycerine will evaporate and the paint becomes less sticky by the time you are ready to use it.

paper

The quality of your finished work will be affected by the type or character of the paper you write on. Your choice will largely depend on the subject matter, the scale of your piece and the effect you want to create with color and/or texture. Buy the best you can afford. Good quality materials always contribute much to the appeal of the finished article.

Small, highly detailed work requires a smooth surface with a slight "tooth" or velvet-like nap which holds the ink or paint, giving crisp edges and fine lines. For larger, less intricate pieces, it is worth experimenting with textured surfaces or handmade papers with petals or grasses incorporated into the sheet. You are likely to find that the written letter will be broken up by heavily textured papers. Soft-surfaced papers, like those for fine printmaking, need care in use because metal nibs catch in the fibers. Shiny surfaces are not ideal, as the nib will skid and ink can make unsightly blobs. However, paint or ink adhesion may be improved (as on other papers which need degreasing) with a light dusting of pounce or ground gum sandarach, brushed off thoroughly before writing. Very absorbent papers are not suitable for calligraphic work using pens, although it may be possible to draw and paint on this type of surface.

Vellum, also known as parchment and made from calf skin, was the traditional surface used for writing before paper was widely and cheaply available. This beautiful material is still used today, but it is expensive and requires special preparation before it can be written on. Good handmade paper is an excellent alternative.

types of paper

HANDMADE PAPER: Comes in individual sheets with four deckle (rough) edges, and is, literally, made by hand.

MACHINE-MADE PAPER: Made on a roller, this paper comes with four cut edges and in a huge variety of colors and textures, not all are suitable for writing on.

MOULD-MADE PAPER: This paper approximates the look of handmade paper at a lower cost. It is made on a roller, so large widths and lengths are available. In sheet form it has two cut and two deckle edges.

surface texture

The surface texture of a sheet of paper is affected mostly by the drying process, but also by the mesh used in the mould.

HOT PRESSED (HP): A smooth surface is made by passing the paper through heated glazing rollers. This refers to watercolor and printing papers.

Not: Sheets of paper are collected and lightly pressed again, which evens out the texture, although it does retain some character. Generally refers to watercolor papers.

ROUGH: Paper allowed to dry naturally, in particular, watercolor paper, takes on the texture of the mat. Mats are blankets of wool felt in which the pulp is pressed to remove excess water. Best suited to large scale, bold work with brush, reed or automatic pen lettering.

LAID: A pattern of horizontal and vertical lines is impressed onto the surface. The reverse side is flat, rather like a not surface.

WOVE: An even texture made by the woven mesh on both mould and mat. Layout paper falls into this category.

paper sizing

Most papers, especially those most suitable for calligraphy, have size added when the pulp is in the vat. Without size, any ink or paint applied to the surface would sink straight in, as with blotting paper. Some papers are surface-sized, but the size in this case tends to repel ink, making the paper difficult to write on, although adding a drop of ox gall liquid to the ink makes writing easier. Ask the supplier about the sizing before you buy. While not necessarily crucial (unless you need to stretch the paper – soaking will remove all the size from surface-sized types), it will help to know before you start work. Keep a file of samples, with notes about sizing and any necessary preparation required, for future reference.

weights of paper

This is measured in grams per square metre (gsm) or pounds per ream (lb). The smaller the number the lighter the weight. Weight is most important when making manuscript books, because you need to consider the bulk of the folded sheets.

paper grain

If machine-made paper is to be folded to make a book or greetings card, you must first establish the grain direction of the fibers. Without doing this, the book or card will not open properly and it will curl at the edges. To work this out, test fold your paper as the diagram shows. Folding with the grain gives least resistance.

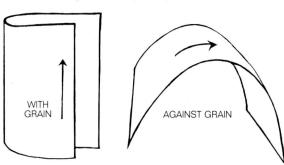

your paper stock

Collect a selection of basic papers, suited to various types of work, but you will always need to have the following close at hand:

LAYOUT PAPER: Buy an A2 pad (420 x 594 mm/ $16\frac{1}{2}$ x $23\frac{1}{4}$ in) if possible, but anything smaller than A3 (420 x 297 mm/ $16\frac{1}{2}$ x $11\frac{3}{4}$ in) is not really economical. More importantly, a smaller pad restricts how you see your work on the paper, and the size of the writing. Layout paper is perfect for practice and roughs; as it is semi-transparent, it is useful for tracing off various stages and refining your designs.

TRACING PAPER: Available in pads or rolls, tracing paper is invaluable for refining designs and lettering as well as transferring the design onto the final paper.

CARTRIDGE PAPER: If of reasonable quality, cartridge paper is useful for all sorts of written or drawn lettering work, though perhaps not always for finished projects.

GLASSINE: For protecting work in progress or as an overlay for finished work. Also used in gilding.

Do not feel restricted to using off-white papers all the time. Art shops stock colored papers for watercolor or pastel work which are also suitable for calligraphy, but the specialist suppliers offer a much wider choice and might provide you with samples of the types they stock for a fee.

Choose large sheets rather than pads for finished work, and buy enough to allow for making mistakes. You will also need extra on which to try colors out first.

looking after paper

Paper is best stored flat, away from extremes of heat and cold and protected from dust. Ensure your hands are clean before handling paper and hold it carefully in a loose curve so it is less likely to crease – particularly important with very lightweight paper.

If you have to roll paper for storage or transport, roll it loosely with the grain and slip it into a wide cardboard tube. Unroll the paper and lay it flat as soon as possible.

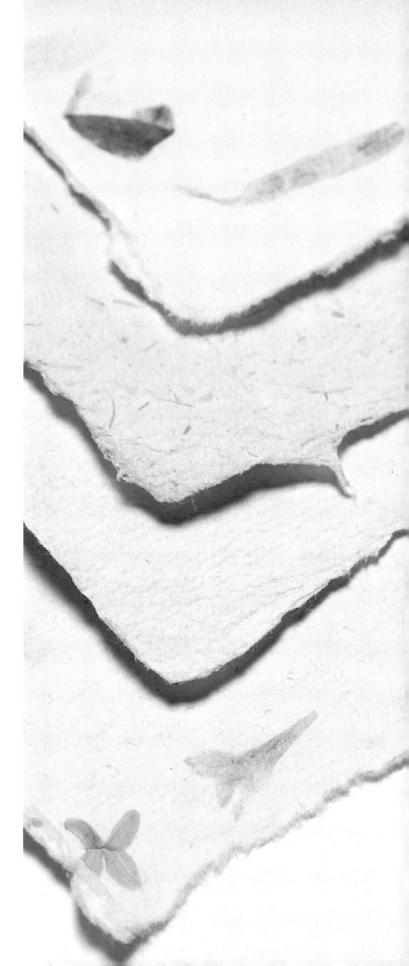

making your ark

In order to make good marks, you need to familiarize yourself with the feel of a broad-edged nib, find out what sort of lines it makes and how the angle of the nib and the amount of pressure you exert will influence those marks.

before you begin

First set up your drawing board at the best, most comfortable angle for you (see page 12).

Some nibs have a greasy coating which can be removed by dipping the nib into boiling water, then into cold water, or by holding the nib in the flame of a match for two to three seconds before dipping it into cold water.

Attach the reservoir and adjust it (1). It needs to be just tight enough to stay in place – too tight and the nib tines will splay, too loose and it will fall off. Always remove and clean the reservoir after use or it will go rusty.

Dip a brush into the ink or paint and apply it to the underside of the nib, feeding it between the nib and reservoir (2). Dipping your nib straight into the ink bottle results in blobs and inky fingers, as the ink flow is not under control. Doing it this way should result in nice crisp strokes.

Wash and dry the nib regularly as you work to stop the nib from clogging. Use a paper towel or rag that doesn't shed fibers, or you could get fuzzy edges. Repeat the process when you have finished writing.

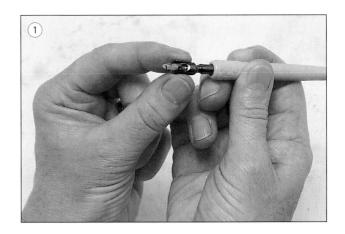

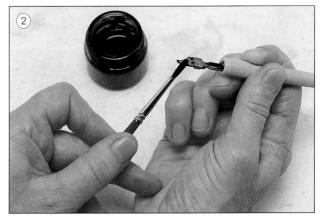

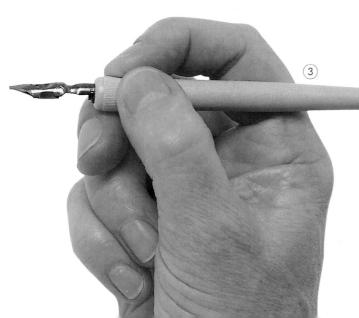

Hold your pen comfortably between thumb and forefinger, sloping it back towards your hand (3). Your arm should be relaxed and supported from elbow to wrist on the drawing board so that hand, wrist and fingers can move freely, enabling you to control the pen more easily.

the first stroke

The nib should make perfect contact on the paper (4), with both tines touching the surface under light, but even pressure. Too much pressure will make the nib splay, give a distorted stroke, and may damage it and the nib. If this is a problem, try holding a bone folder in your other hand. This not only holds the paper in place and keeps your fingers off the surface, it also takes away the pressure from your writing hand. Remember, broad-edged nibs make thick and thin strokes naturally without excess pressure.

If the nib does not write first time, you will need to make side to side movements – on scrap paper – to make the ink flow from the nib properly. If it still doesn't write: check that the reservoir is not too tight, restricting the ink flow; dust the paper, which may be greasy, with powdered gum sandarach, clean it off and have a guard sheet under your hand; or add a little distilled water to the ink or paint which may be too thick to flow well, and test it again. If your first marks are a bit ragged, it could be due to uneven pressure on one side of the nib or a rough surfaced paper making the line break up. The latter can be exploited to good effect sometimes, but not at the beginning.

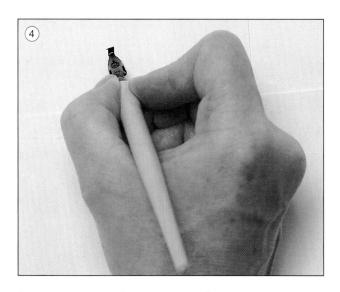

basic pen strokes

First, draw some pencil lines on a sheet of layout paper, then load your nib – start with a large size such as a No. $1\frac{1}{2}$. Holding the pen at an angle of 30° (A) to the writing line, write the strokes shown (B), repeating them at 45° (C and D).

These are the basic building blocks of letters. Try some basic pen strokes using angles of 30° , 45° and 90° (E),

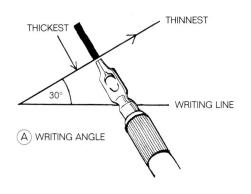

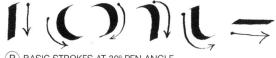

(B) BASIC STROKES AT 30° PEN ANGLE Arrows show direction of strokes.

1 C) 1 C

30° ROUNDED 45° ROUNDED 30° POINTED 45° POINT

30° JOINED

45° JOINED

i.e. ARCHES – 30°

45°

(D) VERTICALS AND SERIFS

Combine different strokes to make more complex patterns. Use different nib-widths for more variations.

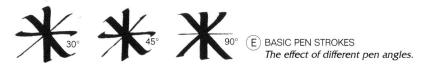

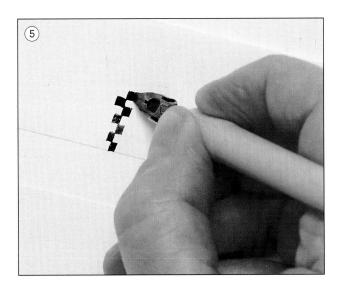

grouping them together according to the angles used, and observe how the resulting patterns differ from each other. The different letter styles all have their own rhythm and practising these strokes and patterns will help you to get the feel of this. Try developing them into zigzags, diamonds, boxes, the possibilities are endless (F and G).

Write the strokes close together, then do them again with wider spacing, concentrating on keeping the spacing even each time, whether it is open or tight (D).

Curves, arches and diagonal lines are reasonably easy to achieve successfully, verticals take a little more practice – work steadily until you can write longish lines without wobbling.

working out the letter height

Before you start to write actual letters, you need to know how to work out the body height, or "x"-height – that is, with no ascenders or descenders – of these letters. Historically, each "style" evolved to a particular size, usually one most suited to the writing out of texts in books, but any style can be enlarged or reduced in proportion to the size of nib you are going to use, by making a nib-width scale (5).

Draw a pencil baseline on some scrap paper, then mark up a series of horizontal steps like a ladder to the required number (you'll find this given on each example pages 24-31). Do this carefully, the strokes should be joined accurately top and bottom to give a true size. When all the marks have been made, draw in a line across the top. Calculate the height of capitals, ascenders and descenders and even line spacing in the same way.

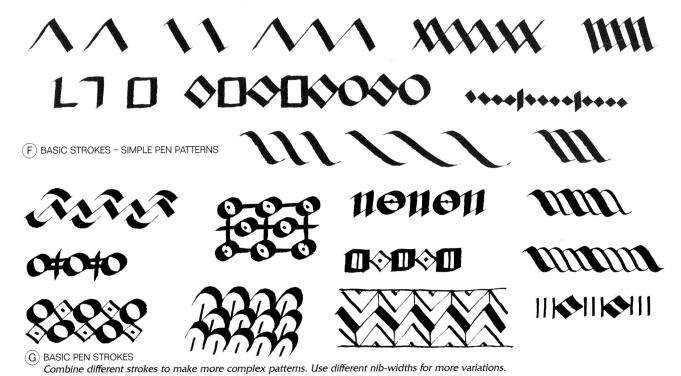

ruling up

You can transfer these marks for letter height to paper to give a series of writing lines in two ways. Either set a pair of dividers to the correct measurement and "walk" them down the page, or make a paper ruler (H) and tick off the marked spaces with a sharp pencil before ruling up.

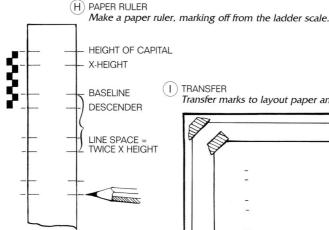

If you don't have a T-square, make the first mark of your scale a measured distance from the top edge at both sides of the paper. Continue the marks down both sides, taking care to be accurate, then rule lines across joining the marks (I).

Transfer marks to layout paper and rule up, joining the pencil marks.

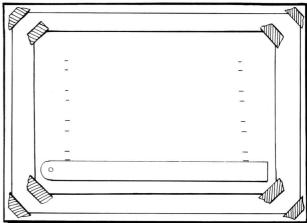

(J) WORD SPACE

Approximately one lower case "o".

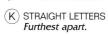

STRAIGHT AND CURVED LETTERS Have less space between them.

(M) TWO CURVED LETTERS Closer still.

(N) COUNTERS Spacing between letters should look even and equal to the space inside the letters (counters).

principles of spacing

Good spacing is crucial to the success of your lettering. If it is poor, legibility will suffer and the reader's interest will be lost. Here are the basic guidelines:

A word space (I) should be equal to approximately one lower case "o". Two straight letters together (K) are furthest apart, there should be slightly less space between a straight letter and a curved one (L) and two curved letters together (M) have the least space between them. What you are actually doing is making visual compensation for the visible space within the letters (counters) (N). Mechanical spacing doesn't really work, it should look even.

analyzing letterforms

You have looked at how to get your pen ready to write, tried some strokes and got used to the feel of the pen. Now is the time to look at some examples of different hands which will be used in the projects later in the book.

Each one has its own characteristics which can be analyzed using a formula devised by the English calligrapher Edward Johnston, initially to help him, and later his students, to understand the principles of good

lettering. The criteria work for any script; ancient or modern.
THE WEIGHT of the letter: that is, the thickness of
the heaviest stroke. This gives you the unit of
measurement for judging letter height.
THE ANGLE of the pen to the writing line. Use a sharp pencil and tracing paper to mark the angles, then use a protractor to check them. Note where angles may be
steeper or flatter to avoid inconsistencies in weight. The FORM of the letter. This is dictated by the pen
angle, but look at the letters "o" and "a", to give a sense of the form (round, oval or angular). Note how the serifs are made (see page 25).
THE NUMBER OF STROKES needed to make each
letter. Look at where the pen lifts occur – after the
"pull" strokes and at the ends of serifs. THE ORDER OF STROKES. This follows naturally from
left to right and top to bottom.
THE DIRECTION OF STROKES. Do they go up or
down or diagonally? Broad-edged nibs write best
pulled towards you, pushed away the ink may sputter.
☐ THE SPEED OF WRITING. Look for joins between
THE SPEED OF WRITING. Look for joins between letters and strokes which overrun.
THE SPEED OF WRITING. Look for joins between letters and strokes which overrun.
☐ THE SPEED OF WRITING. Look for joins between
THE SPEED OF WRITING. Look for joins between letters and strokes which overrun. make your writing practice effective Be systematic. Study the examples one at a time
THE SPEED OF WRITING. Look for joins between letters and strokes which overrun. make your writing practice effective Be systematic. Study the examples one at a time and stick with it for a while. It is important to be
THE SPEED OF WRITING. Look for joins between letters and strokes which overrun. make your writing practice effective Be systematic. Study the examples one at a time and stick with it for a while. It is important to be familiar with and understand the structure of the
■ THE SPEED OF WRITING. Look for joins between letters and strokes which overrun. make your writing practice effective ■ Be systematic. Study the examples one at a time and stick with it for a while. It is important to be familiar with and understand the structure of the script before you begin to write, so follow the
 ■ THE SPEED OF WRITING. Look for joins between letters and strokes which overrun. ■ Make your writing practice effective ■ Be systematic. Study the examples one at a time and stick with it for a while. It is important to be familiar with and understand the structure of the script before you begin to write, so follow the analytical principles given and look carefully at
■ THE SPEED OF WRITING. Look for joins between letters and strokes which overrun. make your writing practice effective ■ Be systematic. Study the examples one at a time and stick with it for a while. It is important to be familiar with and understand the structure of the script before you begin to write, so follow the
■ THE SPEED OF WRITING. Look for joins between letters and strokes which overrun. ■ Make your writing practice effective ■ Be systematic. Study the examples one at a time and stick with it for a while. It is important to be familiar with and understand the structure of the script before you begin to write, so follow the analytical principles given and look carefully at the shapes. It's easy to copy the given examples,
■ THE SPEED OF WRITING. Look for joins between letters and strokes which overrun. ■ Make your writing practice effective ■ Be systematic. Study the examples one at a time and stick with it for a while. It is important to be familiar with and understand the structure of the script before you begin to write, so follow the analytical principles given and look carefully at the shapes. It's easy to copy the given examples, they give you the means to achieve an end (your completed project), but knowing how to analyze the letterforms will inform your writing.
□ THE SPEED OF WRITING. Look for joins between letters and strokes which overrun. make your writing practice effective □ Be systematic. Study the examples one at a time and stick with it for a while. It is important to be familiar with and understand the structure of the script before you begin to write, so follow the analytical principles given and look carefully at the shapes. It's easy to copy the given examples, they give you the means to achieve an end (your completed project), but knowing how to analyze the letterforms will inform your writing. □ You could make your first efforts with double pencils,
□ THE SPEED OF WRITING. Look for joins between letters and strokes which overrun. make your writing practice effective □ Be systematic. Study the examples one at a time and stick with it for a while. It is important to be familiar with and understand the structure of the script before you begin to write, so follow the analytical principles given and look carefully at the shapes. It's easy to copy the given examples, they give you the means to achieve an end (your completed project), but knowing how to analyze the letterforms will inform your writing. □ You could make your first efforts with double pencils, which make the letter structure even clearer. Bind
□ THE SPEED OF WRITING. Look for joins between letters and strokes which overrun. make your writing practice effective □ Be systematic. Study the examples one at a time and stick with it for a while. It is important to be familiar with and understand the structure of the script before you begin to write, so follow the analytical principles given and look carefully at the shapes. It's easy to copy the given examples, they give you the means to achieve an end (your completed project), but knowing how to analyze the letterforms will inform your writing. □ You could make your first efforts with double pencils, which make the letter structure even clearer. Bind two pencils (HB) together with masking tape and
□ THE SPEED OF WRITING. Look for joins between letters and strokes which overrun. make your writing practice effective □ Be systematic. Study the examples one at a time and stick with it for a while. It is important to be familiar with and understand the structure of the script before you begin to write, so follow the analytical principles given and look carefully at the shapes. It's easy to copy the given examples, they give you the means to achieve an end (your completed project), but knowing how to analyze the letterforms will inform your writing. □ You could make your first efforts with double pencils, which make the letter structure even clearer. Bind two pencils (HB) together with masking tape and write with them in the same way as with a pen (6).
□ THE SPEED OF WRITING. Look for joins between letters and strokes which overrun. make your writing practice effective □ Be systematic. Study the examples one at a time and stick with it for a while. It is important to be familiar with and understand the structure of the script before you begin to write, so follow the analytical principles given and look carefully at the shapes. It's easy to copy the given examples, they give you the means to achieve an end (your completed project), but knowing how to analyze the letterforms will inform your writing. □ You could make your first efforts with double pencils, which make the letter structure even clearer. Bind two pencils (HB) together with masking tape and
□ THE SPEED OF WRITING. Look for joins between letters and strokes which overrun. make your writing practice effective □ Be systematic. Study the examples one at a time and stick with it for a while. It is important to be familiar with and understand the structure of the script before you begin to write, so follow the analytical principles given and look carefully at the shapes. It's easy to copy the given examples, they give you the means to achieve an end (your completed project), but knowing how to analyze the letterforms will inform your writing. □ You could make your first efforts with double pencils, which make the letter structure even clearer. Bind two pencils (HB) together with masking tape and write with them in the same way as with a pen (6). □ Aim to write how you know it should look, not how you think it should. □ Start with capitals, they are easier to cope with,
□ THE SPEED OF WRITING. Look for joins between letters and strokes which overrun. make your writing practice effective □ Be systematic. Study the examples one at a time and stick with it for a while. It is important to be familiar with and understand the structure of the script before you begin to write, so follow the analytical principles given and look carefully at the shapes. It's easy to copy the given examples, they give you the means to achieve an end (your completed project), but knowing how to analyze the letterforms will inform your writing. □ You could make your first efforts with double pencils, which make the letter structure even clearer. Bind two pencils (HB) together with masking tape and write with them in the same way as with a pen (6). □ Aim to write how you know it should look, not how you think it should.

writing with paint

Load your pen as already described for ink (see page 19) and adjust the drawing board to a shallower angle, which stops color settling to the bottom of the letters (see page 12).
☐ Stirring the paint often keeps the pigments from separating.
☐ Clean the nib frequently or the paint will dry and clog the nib.
☐ Try writing without a reservoir on the nib. This can be easier, but it does require more frequent and more careful loading of the nib. Practice this technique on spare paper, to gain confidence before tackling a finished piece.
Solve problems with uneven paint flow by adding a drop or two of ox gall or gum arabic liquids to the mix. Ox gall improves paint adhesion as well as flow; gum arabic has similar properties, but adds an extra gloss to the color when dry.
If the paint is inclined to be sticky, put gum arabic in the mixing water rather than in the paint mix.
Always use clean water for mixing and keep a separate jar of water for rinsing out your brushes.

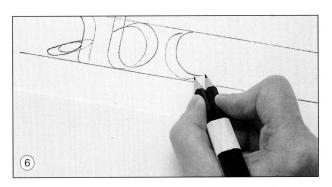

- ☐ Keep writing until you can form the letters without having to refer to the original model.
- ☐ Write words, phrases and sentences. This is much more helpful than just repeating alphabets ad nauseam. Aim to write legible letters fluently, with appropriate letter, word and line spacing.

personal style

Let your own style grow gradually. It's tempting to copy exciting pieces of modern calligraphy without knowing the thought processes behind them. If you do copy something, use the letter analysis formula to try and understand what makes it work. Try to avoid any mannerisms; incorporating these will not help with your own personal style. You really don't need gimmicks to bring a sense of style to your work, just study the seven constants in Edward Johnston's formula.

The following examples and their variations are not exhaustive. Use them as a springboard from which to jump into your own experiments.

ROMANCAPITALS

Skeleton or monoline capitals show the geometrical construction and the relative proportions of these letters. They are the foundation of the capitals on the opposite page. The basic grid for these letters is a circle within a square. One-eighth of the square is cut off at each side, leaving a rectangle which visually is equal to the area of the circle.

the letters fall into family groups:

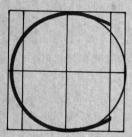

round letters O C D G Q

Based on the circle, with straight sides relating to the rectangle. O and Q should curve very slightly through the writing lines top and bottom. C and G have the top stroke slightly flattened.

rectangular letters **A H N U V X Y Z**Letters with straight sides and diagonals.
The cross bar of H is slightly above the center, on A it is just below the center.

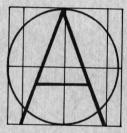

extra wide letters M W

W is made up of two Vs side by side (i.e. two rectangles). M is the full width of the square at its base, although strokes 1 and 4 begin on the edges of the rectangle.

narrow letters 1) **B E F K L P R** 2) **S J**Use half-width squares for narrow letters. The curves are still based on circles. The cross bar of F is lower than that of E to balance the white space. The bottom cross bars of E and L are slightly longer than the upper ones.

ABCDEFGHI JKLMNOPQR STUVWXYZ

Try writing these letters with a pencil first between lines ruled 25 mm (1 in) apart and then use double pencils (see page 23). Skeleton letters can be used in their own right, not just as an exercise, so follow up the pencil letters using a fine nib. To put "flesh" on your skeleton letters, write them again with double pencils (see page 23).

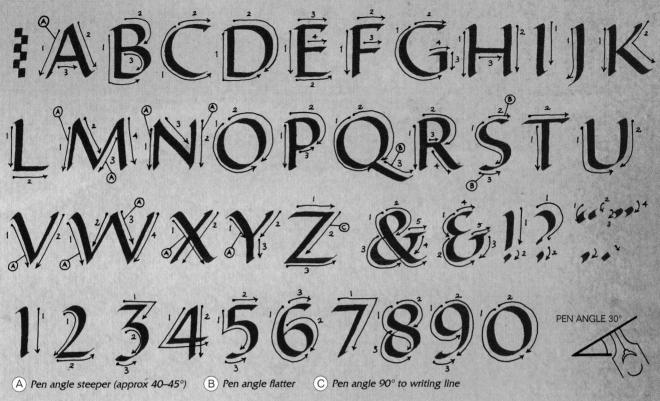

These letters are usually used in a formal way, as they were originally in stone inscriptions or as important headings in manuscripts and books.

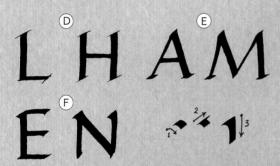

how to make serifs

In the example above, the serifs are really small ticks made as the pen is lifted off the paper. These can be varied in three ways: (D) fine lines made with the pen at 90° to the writing line, (E) slab serifs written at approximately 30° (the same as the rest of the letter), (F) built up with three strokes to make a triangular shape. This requires some care to make the strokes blend into each other.

THE QUICK BROWN FOX JUMPS OVER THE LAZY DOG

spacing

Space the letters to look equal, with the word space slightly less than O. If the letter spacing is too tight, dark patches will appear and the Os will look like holes. If too open, the letters will not connect as words. The line space is the same as the height of the letters.

FOUNDATIONHAND

Edward Johnston chose an English 'Caroline' minuscule (from the manuscript Harley 2904 in the British Library) for his foundational hand, which he developed as a basic round hand for formal writing. The example given here owes much to those early researches, but is adapted for modern use and has smaller serifs. The foundation hand is a useful hand for formal work and Roman capitals are usually used with these lower case letters. It is based on a circle within a square, where the rectangle equals the area of the circle.

the letters fall into family groups:

round letters b c d e o p Bottom curve of p, top curves of d and q are flattened.

arched letters a h m n r u m is twice the width of n. u follows the lower part of o.

diagonal letter strokes k v w x y z w is twice the width of v. Top of x is inside the rectangle, bottom is outside. Bottom stroke of z is slightly wider than the rectangle.

straight letters f i j l t Top curve of f is flattened and cross bar is below x-height. Cross bar of t is on x-height line.

> ungrouped s g Top of g is smaller than o, bottom half is wider, a flattened oval.

relative proportions of letters

Lower case letters are \(\frac{3}{5} \) height of the capital. Ascenders and descenders are $\frac{2}{5}$ height of the capital.

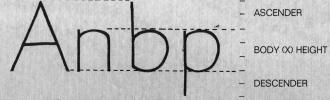

variations in letter weight

At the standard 4 nib widths x-height for any nib, the letter weight can be altered by using a thinner or thicker nib, using the same standard x-height. This is useful when you start to design pieces of work.

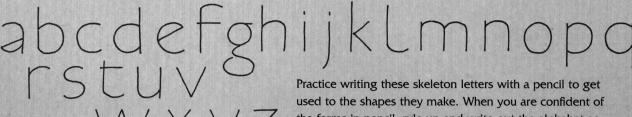

the forms in pencil, rule up and write out the alphabet as shown opposite using pen and ink.

spacing

Space the letters so that the white space within and between them looks even. Word space is slightly less than o. Line space is twice the x-height.

The quick brown fox jumps over the lazy dog

modifications to joins

To improve the appearance of even letter spacing, the first letters are reduced slightly in width.

ea fl ff la ri ry tt

ITALICS

The understanding of the structure of Roman capitals will help when looking at italic capitals, but here the form is oval, not circular. The letter width is two thirds of the height, which alters the relative proportion of all the letters. Look at the internal spaces as well as the overall letter width. This hand is generally used for informal work, although the upright italic has a classic elegance.

lower case letters: related forms

a is the key letter, made up of three strokes. 2 is flattened, 3 is parallel to 1. Most lower case letters follow this form, but fall into rough groups according to the direction of the first stroke. The rhythm of writing the strokes is important. All upstrokes are pushed and the arches spring out from mid-stem.

anti-clockwise, pointed base a d g q u

rounded base c e f o s t (f can extend below the baseline) clockwise, arched letters b h m n p r diagonal letters i j k v w z y z

hhad tfs related spaces and position of cross bars Spaces between arch and stem at the top of letters relates to those at the base.

Cross bars hang from the x-height line. The top curve of s relates to that of f.

variation in letter weight

As described on page 22, if you establish the standard capital and x-height for any given nib, you can vary letter weight by writing at the same height with either thinner or thicker nibs.

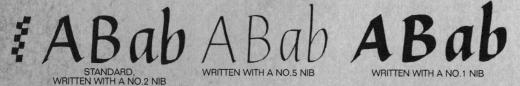

flourished capitals

Italic's cursive nature lends itself to flourishes and they are fun to do. Make them as an extension of part of the letter, usually from the thin rather than the thick stroke, though there are exceptions. They should look natural and not disguise the letter shape. Practice them in pencil first to see how they work. The pen-written ones should retain the vitality of your practice letters. Flourishes on D are similar to those for B. On lower case letters, flourishes spring from ascenders and descenders, although some letters can be extended at the end of a line to help balance centered layouts, or even to make a decorative feature at the end of a piece.

AAABBCCEEEFGGG HHHAJKKZLMMM NNNPPPQQRKRSS TTUIL NVWWWXX MYZZ && Jobba fgpkragtyz,

EABCDEFGHIJK LMNOPQRSTU jabcdéfghijklmn OPGISTUNINE STER 1234567890

spacing

Space capitals visually. Line space is the same as the height of the capitals. Lower case letters need generous interlinear spacing because of the tall ascenders and descenders – twice the x-height as a minimum. Start with generous letter spacing too, then practice closer spacing, adding joins for a more cursive, informal feel.

The quick brown fox jumps over the lazy dog

VERSALS

Versals were originally used as initial letters of verses, as the name suggests, in bibles and other religious books. They provide an effective contrast to most scripts written with broad-edged nibs, but can also be used in their own right as blocks of text. The skeleton capitals on page 24 will help with proportions. The form is round, based on O, although the inside shape of O is quite oval. Most often used in a formal way, in modernized form, they can also be used effectively in informal designs.

letter construction

STRAIGHT LETTERS Outer strokes curve slightly inwards

CURVED LETTERS Make inner strokes first. Curved outer strokes start flatter.

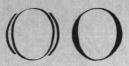

DIAGONALS In each category, the third stroke fills in the gap created

direction and angles of pen movement in letter construction

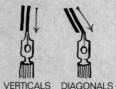

family groups

round OCDGOQ relate to O (strokes 2 & 5 on C, 2 on G are flattened).

PRB bowls relate to O. Width of curves needs to be slightly wider than normal stems, to look equal.

S inner curves (strokes 2 & 3) are rounded.

diagonal AMNVWXYZ straight stem EFHIJLTU

letter height

Twenty-four nib-widths or eight times the stem width of three strokes. The simplest method is to measure three nib-widths and multiply that by eight.

Practice writing with confidence to avoid wobbles! Learn the shapes so that you can visualize them before you write. An alternative is to draw them in pencil first and fill in with paint and brush, though the end result will differ slightly from penwritten letters. Don't overload the brush otherwise the serifs will not be as fine as they should.

THE QUICK BROWN FOX JUMPS OVER THE LAZY DOG

spacing

Space visually, as with Roman capitals. Word space is approximately the inner space of O and the line space is the same as the height of the capitals.

Rule up and write versals between two pencil lines to begin with, but as you gain in confidence and can keep the height even, try to write without the top line.

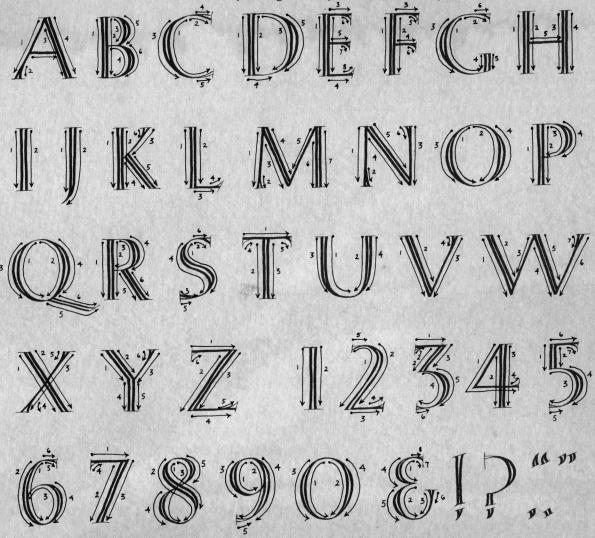

lombardic versals

These generously proportioned letters were common in medieval manuscripts from the 13th–15th centuries. Often highly decorated or on decorative backgrounds, they relate more closely to uncials (see page 6) than to Roman capitals.

ABCOEFGHI IRLMNOPQ RSCUVUXYZ

AB AB

variations

Experiment with the letter weight using different nib-widths at the same height: thicker nibs for heavier weight, thinner nibs for light weight letters. Modern versals without serifs can be written upright or slightly slanted. With the latter, as the O becomes more oval than round, the weight of the letter shifts.

practice, sets

The following projects will help further your experience of using broad-edged nibs, as well as exploring the contrasts that can be made by using different nib sizes.

alphabet

This project explores how the "color" of lettering can be varied even in black, by using the same hand but written in different weights and sizes. This idea can be used in the writing out of prose or poetry to add interest and emphasis. Assess the quality of the letterforms as you write so you can improve as you go on.

specific materials Essential equipment (see pages 8–9) Dip pen and nibs, Nos $1\frac{1}{2}$, $2\frac{1}{2}$ and 4 Repositionable glue Cartridge paper

Work out the letter height for Roman capitals by making nib-width ladder scales for the three nibs you are going to use (see pages 24–25). Rule up pencil lines on layout paper and write out each alphabet in black ink at the correct height.

Rule up more lines on a fresh sheet of layout paper. This time use the smallest nib, No. 4, to write an alphabet at the largest height, the largest nib, No. $1\frac{1}{2}$, at the intermediate height and the middle nib, No. $2\frac{1}{2}$ at the smallest size. You will find writing large letters with a fine nib quite tricky – it takes some practice and a lot of control. Observe the difference in the character of the letters between the two sets of alphabets (1).

RABCDEFGHIJ
KLMNOPQRS
TUVWXYZ

RABCDEFGHIJKL
MNOPQRSTUV
WXYZ

RABCDEFGHIJKL
MNOPQRSTUV
WXYZ

ABCDEFGHIJK
LMNOPQRSTU
VWXYZ

ABCDEFGHIJK
STUVWXYZ

ABCDEFGHI

3 Cut up the alphabets into strips. Using groups of letters of differing weights, play around with the arrangement until you find one which makes an interesting shape and looks balanced (2). I have used a roughly centered format with quite tight line spacing.

Tack the strips of letters in position using repositionable glue, keeping the lines as straight as possible. This new sheet is known as a paste-up. Lay a sheet of tracing paper over the paste-up to assess the effect without the distraction of stuck-down patch marks.

5 Rule up a fresh sheet of layout paper (following your paste-up layout) making any minor adjustments to the position of the letters. Lay this over your paste-up and write, copying from the layout underneath.

6 Rule up a sheet of cartridge paper. Write it out again as a finished piece, making the best letterforms you possibly can.

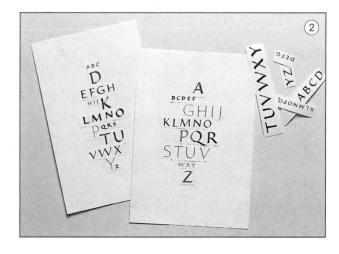

words as patterns

Writing words, particularly in italics which have such bounce and vitality, can help to establish rhythm in your work. This exercise should also help to develop your eye for good letter shapes, letter spacing, where ligatures (joins) can sensibly be made between letters, as well as the pattern possibilities. Choose a few words on a theme (such as musical terms or names of garden herbs) and make your first attempts just in black ink, then turn to color for some interesting effects.

specific materials
Essential equipment (see page 8)
Dip pen and nib, No. 1
Repositionable glue
Gouache in two or three toning or contrasting colors
(such as scarlet lake, cadmium yellow and burnt sienna)
Brushes and palette for mixing gouache
Cartridge paper

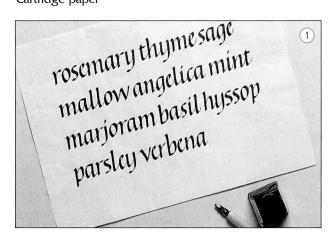

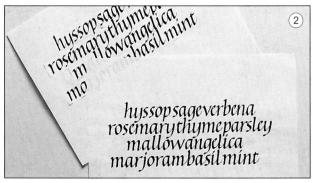

Using the No. 1 nib, make a nib-width ladder to establish the correct x-height for the italic hand (see pages 28–29). Rule up a series of writing lines on layout paper at normal line spacing.

Pollowing your chosen theme, write out the group of words in black ink, without word spaces, in a different order on each of the lines and varying the starting position each time (1).

3 Cut up the words (or photocopies of them) and experiment with combinations of lines and line spacing, deciding how tight this can be before you have to tuck ascenders or descenders into convenient gaps. Try turning words upside down like a mirror image.

4 Tack down one or more variations to make a paste-up and lay tracing paper over the paste-up to disguise the stuck-down patches.

Rule up a fresh sheet of layout paper following your paste-up layout. Lay this over your paste-up and write, copying from the layout underneath (2).

Repeat the exercise in color (see page 15 for how to mix gouache for writing). Use separate brushes to apply each of the colors you use to the nib.

When you are happy with it, rule up a sheet of cartridge paper: start by transferring all the relevant marks by using a paper ruler or dividers (see page 22). Write it out again as a finished piece.

hyssopsageverbend rosemarythyme rosemaru mallówanaelic

Choose contrasting colors like red and yellow or blue and yellow. Write a letter or two in the first color, then feed in a little of the second and continue to alternate the colors as you write. Wash the nib out and start afresh fairly frequently to preserve the clarity of the colors.

basil mint sage parsley mallow

Do all the writing in one color, but while the paint is still wet, drop in blobs of the second color, so that the two run into each other (above right). This works best when the base color is lighter than that dropped in.

Alternatively, write the words in plain water and drop color in before the

mallowangelicasage Moppundiphudabbs

color variations

water dries out (below right).

designskills

As soon as you have become familiar with the letterforms in the examples (pages 24-31), you'll be keen to exploit your new skills and make something – a greetings card perhaps, or a menu for a dinner party. The next step is to understand how the design and general concept of a finished piece will affect it. Develop your awareness by looking at everyday things like notices and book covers, and particularly at the work of well-known calligraphers. Consider what constitutes formality and how the size, weight and color of the letters can focus the reader's attention.

sort out your ideas

Before you start a design, there are a few simple questions to ask yourself, which will help you to organize the elements you want to include. Most of the projects in this book use only small amounts of text, but you need to have these principles in mind, even for very simple pieces.

- ☐ Who or what is the piece for?
 ☐ How hig do you want the piece to be? This w
- ☐ How big do you want the piece to be? This will tend to dictate the size of letters you can use.

Ordinary carbon paper is fairly greasy and the marks it makes cannot be erased easily, so it is not really suitable for transferring decorative motifs onto finished work. Instead, here are two easy methods you could try.

The first technique works best if the original is on thin tracing paper. Turn over the sheet with the design on it and scribble over the back of all the lines with a 4B or 6B pencil to give a good carbon base. Position the drawing face up in the correct position on the finished piece and, holding it securely in place, use a 6H pencil to redraw over the design. Press down just hard enough to transfer the design without indenting the surface.

To make your own reusable carbon paper, cover a small sheet of thin tracing paper with a thickly scribbled, even layer of carbon from a 6B pencil. Rub it in with your finger to get good adhesion and dust off any surplus. Alternatively, dab Armenian bole held in a thin muslin pouch over a small sheet of tissue paper to give a thick, even layer. Rub it in and dust off the surplus. Use either type as you would normal carbon paper, but any superfluous lines may be removed carefully after painting or writing using a soft eraser.

transferring designs

- ☐ Is it a formal or informal piece? The answer might help with the next question.
 ☐ What letterforms shall I use?
 ☐ What are the most and the least important elements.
- ☐ What are the most and the least important elements involved? Logically, the most important needs to be most prominent.
- How can I arrange the elements in the space for best effect? The white space around the words is important too, so consider the margins as part of the design
- ☐ Will color play a part in the design, and if so, which color(s)? The mood or purpose of the piece should help you here.
- What materials shall I use? Colored paper, paint, ink?Do I want to include any decorative elements and if so, what sort?

Once you have asked yourself the above questions, think about the following concepts:

FORMAT: This principle relates to the second question. The length of lines of the prose or poetry will be a deciding factor in the shape of your finished piece – square, rectangular, vertical or horizontal. Follow the natural pauses, such as ends of phrases and punctuation marks for the line breaks, to keep both the rhythm and sense of the language clear.

SPACING: From the practice projects on pages 32–35, you will have gained an appreciation of how line, word

TWINKLE

TWINKLE LITTLE STAR HOW I WONDER WHAT YOU ARE! CONTRAST IN FORM

twinkle *
twinkle
twinkle
twinkle
twinkle
twinkle
how

* now
1 wonder
what *
* youare!

CONTRAST IN WEIGHT

TWINKLE
TWINKLE
LITTLE
STAR
HOW I
WONDER
WHAT
YOU ARE!

CONTRAST IN TEXTURE

TWINKLE
TWINKLE
STAR
HOW I
WONDER
WHAT
YOU
ARE!
UP ABOVE
THE WORLD
SO HIGH
LIKE A
DIAMOND
IN THE
SKY

CONTRAST IN DIRECTION OF WRITING

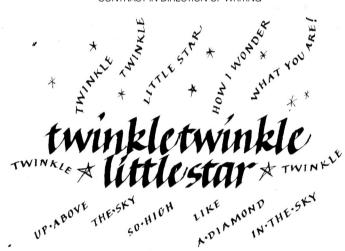

CONTRAST IN COLOR

TWINKLE
TWINKLE
LITTLE
STAR*
HOW I
WONDER
WHAT
YOUARE!

and letter spacing affect the visual texture of a finished piece. Use modified spacing, increasing or decreasing space, to add emphasis.

VARIETY: This concept is essential to gaining and then retaining interest. If you are working with more than just a few words, alter the height and/or weight of the text where appropriate by changing the nib size. Color also brings variety.

EMPHASIS: This principle relates directly to the fifth question. Think about how you could use the size, weight and color of the lettering to pick out the most important words.

Look at the examples above which illustrate how many different ways there are to introduce contrast into your work, then try them out for yourself using a favorite poem or piece of prose.

planning the finished work

The next stage is planning your finished work. The planning stage is important for any size of project, so don't be tempted to leave it out. It will enable you to sort out your ideas, reject those that don't work, improve on those that do, as well as tuning up the quality of your writing as you go through the process. By the time you are ready to transfer the design onto good paper, you should be reasonably confident of success.

MAKE THUMBNAIL SKETCHES: See below for possible permutations. Sketch your ideas in pencil at a small size on layout paper. See how they look as you alter the position of the elements or vary the weight of the letters by scribbling blacker lines. Try to develop a flexible attitude and play around with all the possibilities until you find a solution that works best for you and will give you promising results.

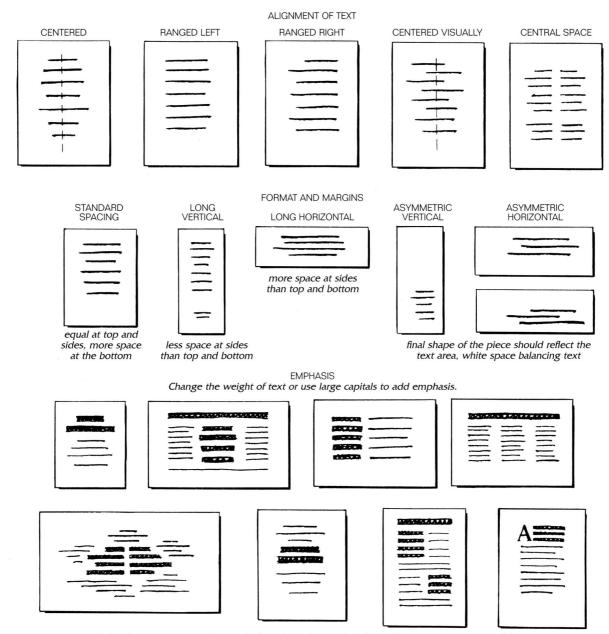

Darker lines suggest heavier weight for titles or focal point of text. There are so many possibilities.

A THUMBNAIL SKETCHES

To decide layout and format.

₹ Rebus in adversis

B RULE UP AND WRITE OUT TEXT Including title, etc. draw out decoration and any large capitals.

Rebus in adversis

animum submittere noli!

© CUT OUT AND PASTE DOWN

All elements following thumbnail. Check line spacing by
matching pencil lines on cut strips to those on base paper.

D FIND BEST TEXT-TO-SPACE RATIO

Use dark card strips.

(E) COLOR TRIALS AND MOCK UP (if appropriate)

MAKE A PASTE-UP LAYOUT: With your chosen design in mind (A), rule up and write out the text in ink using the sizes, weights and colors you think will suit the shape of the finished work. Write or draw out any extra decoration or large capitals (B). Cut out all the elements into strips or individual pieces. Assemble all the pieces on a sheet of plain paper, following the thumbnail sketch (C). You may want to make changes – a layout at full size can often have quite a different feel when compared to the initial sketch. Rewrite incorporating any changes and continue to assemble the pieces in this way until you are satisfied with the result. Use strips of dark colored card to decide the margins around the lettering (D).

Draw out the final shape you have chosen with the aid of the card strips onto a sheet of layout paper. Use a paper ruler to transfer the appropriate line spacing and rule up, as described on page 22. Stick everything into place using a repositionable glue; it allows you to move the pieces about easily to get the text accurately squared up with the lines on the layout paper.

Lay some tracing paper over your paste-up to disguise the patch marks of the stuck-down pieces and give a better idea of the finished effect. Check the margins again with the card strips, adjusting them if necessary.

Before you start the finished work, if you are going to use a colored paper, remember that it will look rather different compared to plain black on white, so it is worth taking the time to do a trial paste-up with the materials you intend to use (E). Make a mock-up for books.

Measure and cut your chosen final paper to size (plus an allowance for trimming out). Tack it down onto the drawing board with masking tape and rule it up using the paste-up and paper ruler as your guide, then write out the text with confidence (F).

Rebus

(F) RULE UP AND WRITE OUT FINISHED PIECE

developings

The projects that follow will ease you through the stages of planning and executing a complete design, reminding you of the different processes and making most of the design decisions for you, but you might like to make alternative choices to adapt the ideas and make them your own.

letterhead with

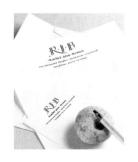

This project designs some simple, personalized stationery using a monogram of decorated letters. It combines three elements into a balanced design, using three nib sizes, and shows how to make artwork for conventional printing in two colors.

specific materials

Essential equipment (see pages 8–9)
Dip pen and nibs, Nos $2\frac{1}{2}$, $3\frac{1}{2}$ and 4
Gouache, scarlet lake and opaque white
Brushes and palette for mixing gouache
Repositionable glue
Thin white card, 200 gsm (75 lb cover stock) mixing white card, 200 gsm (75 lb cover stock) mixing gouache

Thin white card, 200 gsm (75 lb cover stock) minimum T-square

Set square

A4 (297 x 210 mm/ $11\frac{1}{2}$ x $8\frac{1}{4}$ in) white wove paper, 100 gsm (such as Conqueror), this could be ordered from the printer

Look again at the design practicalities discussed on page 36. With these concepts in mind, think about the design of the piece. Remember that the size and position of the monogram and address should not be too big, allowing enough room for the writing beneath. The positioning of the design should look right when the paper is folded to go in the envelope. Will the correspondence on this letterhead

be hand-written or typed? This may have a bearing on the style and position of the design on the page.

2 Start by drafting out ideas as thumbnail sketches including the three elements of monogram, name and address, working towards a balanced layout.

Work on the monogram, starting with pencil scribbles then moving onto pen roughs (1). I have picked a hollow versal written with a slanted pen, using a No. $2\frac{1}{2}$ nib for the letters and a No. 4 nib for the bud decoration. Try out different colors for the letters.

Choose an appropriate script for the name and address (2). I have used a plain italic which complements the style of the monogram, but does not detract from it. Rule up and write out the wording, balancing the size of these two elements against the monogram. I settled on a No. $3\frac{1}{2}$ nib for the name and a No. 4 nib for the rest.

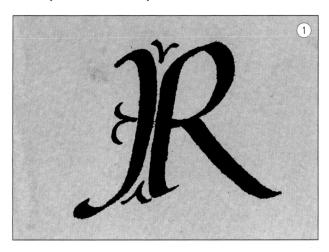

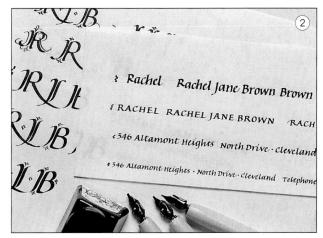

Reliane. Brown Rachel Jane. Brown Rachel Jan

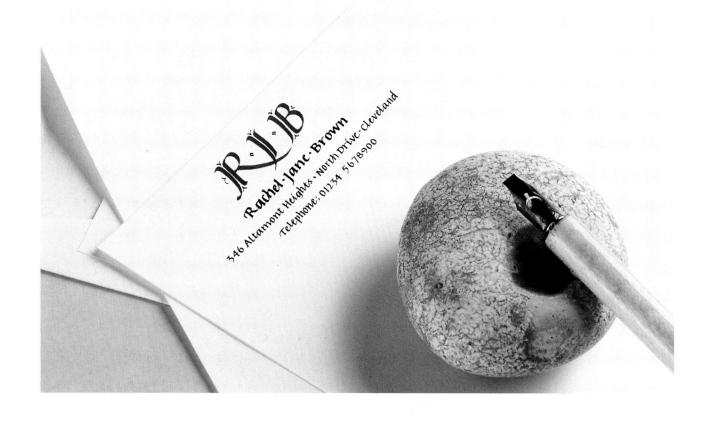

Mark the centers of each line, then cut out the lettering (or photocopies of it) and make an A4 paste-up layout, assessing the correct line spacing as you put all the elements in place (3).

6 Finalize the lettering at the x-height on the paste-up by practicing until you are confident to go ahead with the finished version. Sort out any problems with spacing and color (4).

Write everything out again, neatly, on a fresh sheet of layout paper. Repeat the monogram in black ink only, tidying up any rough edges with opaque white gouache.

Now to make the artwork for printing. First make a paper ruler, marking up the x-heights and baselines from your paste-up. Rule up an A4-sized rectangle onto thin card. Using a T-square and set square, transfer the measurements from the paper ruler to the card and rule them in lightly.

Orimin out all the elements of the neatly rewritten version. Put them face down on some clean scrap paper and spread a thin layer of glue on the back, one piece at a time. Position each piece accurately on the card, matching the pencil center and baselines. Clean off any surplus glue carefully with a plastic eraser or a ball of dried rubber cement, and erase all pencil lines. Add trim marks at the corners of what will be an A4 sheet.

10 Cover the card with tracing paper. On this overlay mark up instructions for the printer, specifying colors and type of paper (5). You can use colored pencils or felt-tip pens (to approximate the color you have specified in your instructions) to color in the letters so that the printer knows your intention exactly.

If you wish, you can reduce the complete design by about 50% on a photocopier and make another piece of artwork, as previously described, for A6 headed notecards (148 x 105 mm/ $5\frac{3}{4}$ x $4\frac{1}{8}$ in) or with the monogram only, for matching envelopes.

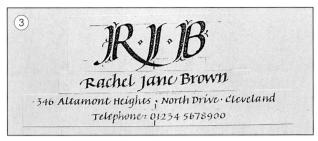

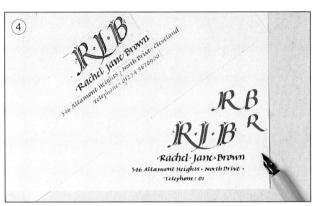

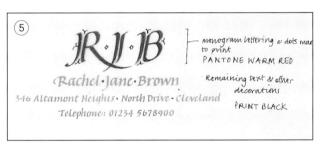

alternatives-

The monogram can be as simple or as complex as you wish to make it. Here are some ideas, based on versals, which could be used as a basis for your design. These letters would work in one or two colors and could be used in many other ways, for example as initial letters at the start of a piece of poetry or prose.

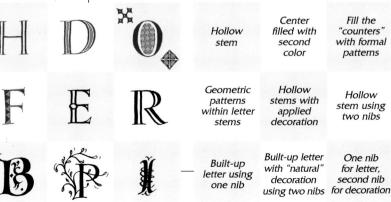

greetingcards

I have made cards like this for family and friends for as long as I can remember, and still enjoy the challenge of coming up with fresh ideas. Your design need not be complex to be effective; you could pick a series of phrases like these, all connected with birthday, celebrations and good wishes, and then use your design skills to dovetail them together. This project uses two styles and three weights of lettering; modern versals with calligraphic weighting, italic capitals and a cursive italic. It employs change of weight, color and direction of writing for its impact and interest.

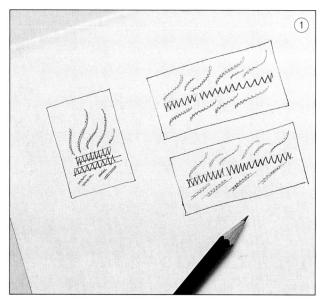

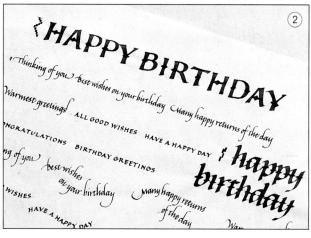

specific materials
Essential equipment (see pages 8–9)
Dip pen and nibs, Nos 2½, and 4
Repositionable glue
Gouache, scarlet lake, cadmium yellow and gold
Brushes and palette for mixing gouache
1 sheet HP watercolor paper, 300 gsm (140 lb)
Sable brushes, Nos 0 and 00
Scalpel, cutting mat and metal ruler
Bone folder
1 sheet colored paper, approx. 150 gsm (40 lb bond)
9H pencil for transferring design

finished size $92 \times 205 \text{ mm} (3\frac{5}{8} \times 8 \text{ in}) \text{ when folded}$

Make thumbnail sketches to experiment with a design, trying both landscape and portrait formats (1).

Write out your chosen text on layout paper. Here, the versals are written at ten nib-widths of a No. $2\frac{1}{2}$ nib to give bold, chunky letters as the centerpiece; the lightly spiky cursive italics with flourished extensions have an x-height of four nib-widths of a No. 4 nib and the italic capitals are at the same height. Write the phrases on straight lines first, before drawing out gently curving lines and writing out the text again (2). This will need some practice to get right, as the uprights should follow the tilt of the curve. Experiment with the flourishes as well.

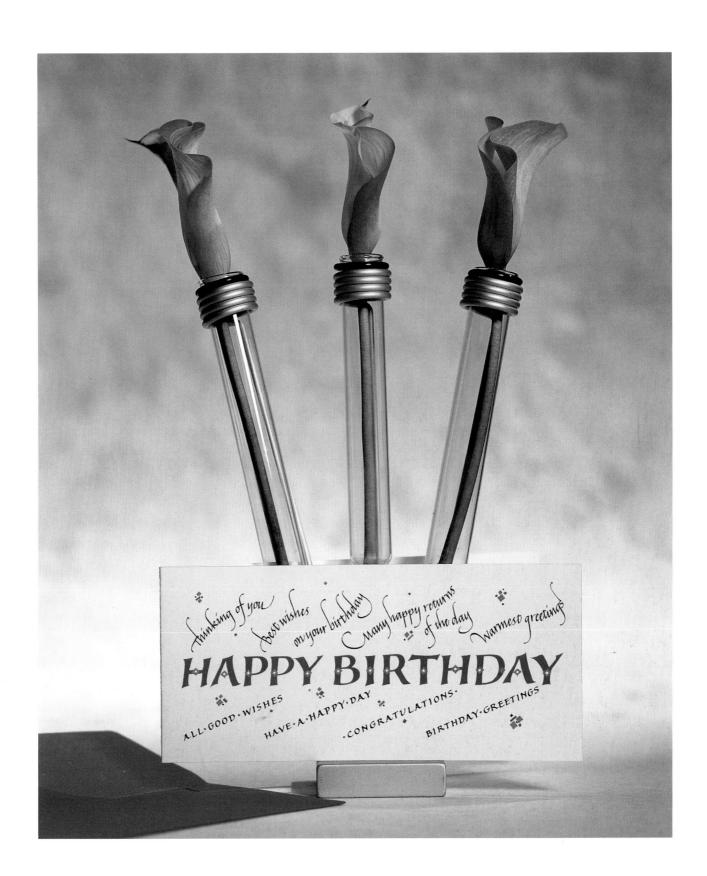

3 Cut out these elements (or photocopies of them) to make paste-ups. I made two to help decide on the design, using strips of black card to indicate the margins (3 and 4). I decided to alter the capitals on curves back to straight lines to avoid a fussy design. It is easier to see and make decisions about this sort of problem at full size.

4 Make another paste-up with an overlay roughed in to show color and decoration on the main wording (5).

5 On a sheet of tracing paper, trace off the chunky versals and the position of the lines for the rest of the text, marking them accurately. If you are not confident about writing on curves straight onto the card, trace in this wording carefully as well (6).

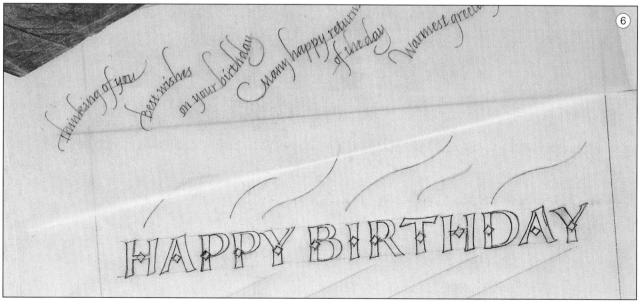

Tack the watercolor paper to the drawing board and rule up the full dimensions of the card (remember to double the width measurement and mark the fold) with trim all round. Transfer your design to the paper (see page 36).

Before you do any writing on the finished piece, try ink and paint out first on a spare scrap of the watercolor paper, as you may need to give the surface a dusting of pounce for the writing to be crisp.

Complete the cursive italics and the italic caps in black ink first (7). Then mix some scarlet lake gouache with a touch of cadmium yellow and begin outlining the versals, using a No. 00 sable brush. Fill in the letters carefully, using a No. 0 sable brush, leaving the diamonds in the letters blank (8).

Pill in the decorative diamonds in the large red letters using gold gouache. To give an extra sparkle and to help balance the design, devise little groups of red, gold and black diamonds on layout paper, which can be moved about on the rough until you are satisfied with their position. Transfer these patterns to the finished piece with pen or brush.

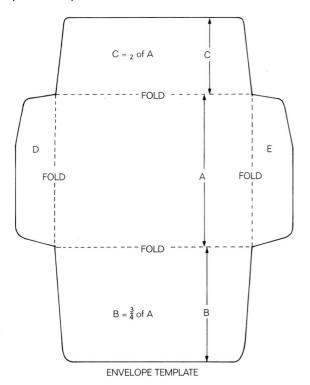

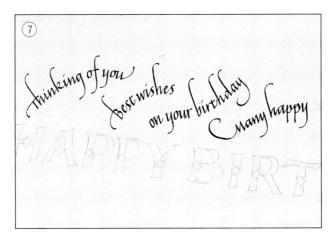

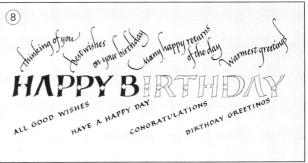

 10^{Trim} out the finished card using a scalpel against a metal ruler. Use a bone folder to make a clean, sharp fold in the card.

1 1 To complete the project, you might like to make your own envelope, especially if the card is not a standard size. The following template and formula can be adapted to any shape.

Make the template on layout paper by drawing a rectangle 8 mm ($\frac{5}{8}$ in) longer and wider than the finished greetings card. B = $\frac{3}{4}$ of A; C = $\frac{1}{2}$ of A; D and E = 25 mm (1 in) minimum, wider for a bigger envelope. Angle the top part of D and E and round the corners off to make it easier to slip the card into the envelope.

Transfer the template to colored paper, then cut the envelope out with a scalpel against a metal ruler, using scissors for the round corners. Score along the dotted lines by aligning the ruler against the pencil line and pressing down with the pointed end of a bone folder. Press all folds flat (B over D and E) and apply glue. Take care not to use too much – slip scrap paper under the flaps to catch any excess.

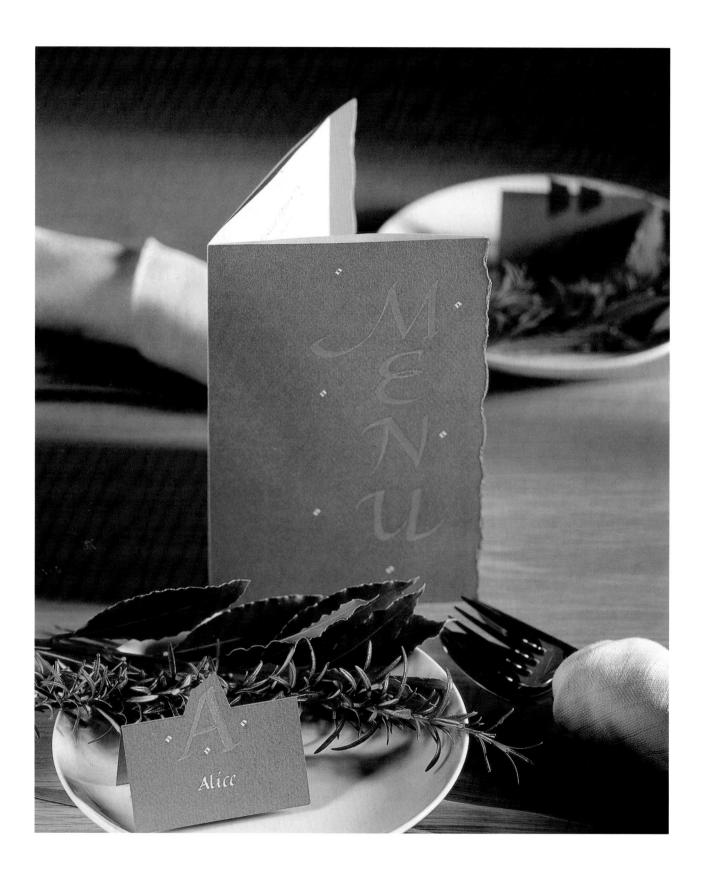

menu and matching place cards

To design a menu and matching place cards you will need to think carefully about the concepts discussed on page 36. You will also need to decide the number of dishes and courses to be served. In this case, the menu is for an informal, three-course summer dinner party at home, for which you need only make one or two menus by hand. For a larger, more formal occasion, you could consider designing something more classic and preparing artwork to have printed (see page 43). I have chosen to use a mid-toned paper for the cover, with a marble-patterned inner sheet – the fresh greens reflect an early summer feel.

specific materials

Cover paper: 1 sheet Canson mi-teintes, 160 gsm

(60 lb cover stock), No. 575 (green)

Menu paper: 1 sheet G F Smith Marlmarque (or similar smooth, marbled paper), 90 gsm (50 lb lightweight

stock), Corinthian green

Dip pen and nibs, Nos $3\frac{1}{2}$ and 4 Automatic pen, No. 3

Repositionable glue

Gouache, mistletoe green, cadmium yellow, gold and opaque white

Brushes and palette for mixing gouache

Gum sandarach (optional)

White pencil (for transferring design)

Scalpel, cutting mat, metal ruler and bone folder

finished size of menu folded from A4 (297 x 210 mm/ $11\frac{1}{2}$ x $8\frac{1}{4}$ in), front flap 137 mm ($5\frac{3}{8}$ in) wide

Decide on the approximate size of the menu card and inner pages. I used an A4 ($11^{1}_{2} \times 8^{1}_{4}$ in) sheet folded asymmetrically for the cover. The inner pages need to be approximately 4 mm ($^{1}_{8}$ in) narrower over all than the cover, to allow for the fold and the deckle edges. Jot down your ideas for cover and inner pages in thumbnail sketches. Think about the most appropriate style of writing for both parts, the type of decoration you might like to incorporate and how the design could be adapted to suit the place cards.

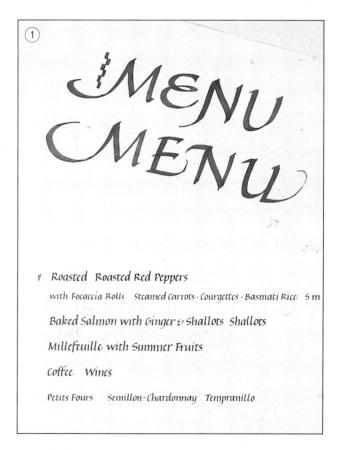

2 Rule up layout paper and write out all the wording for the menu in your chosen hand, deciding the appropriate weights and sizes for the page size and amount of text (1).

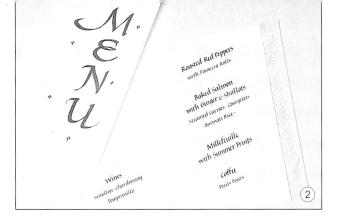

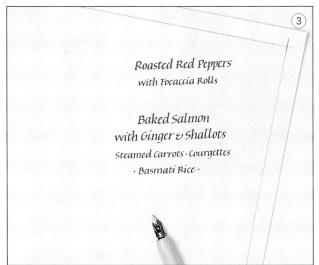

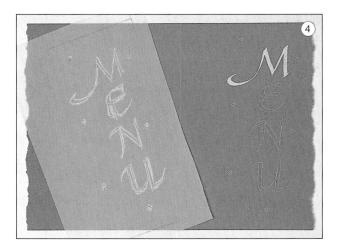

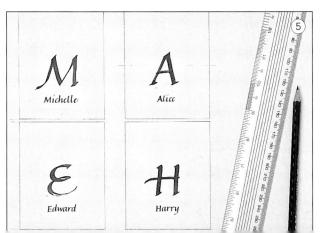

3 Draft some flourished italic capitals for the cover using the automatic pen, and make paste-ups for both cover and menu pages, with careful consideration of the position of the text on the page (2). It is important to standardize on a consistent line space throughout to achieve unity in the design.

A Mix up some of the paint colors you are going to use (mistletoe green and cadmium yellow to match the cover paper, gold for flourished capitals and white for decorations) and try them out, as well as the black ink, on the papers for each section and decide how you will use the color to best effect. You may need a dusting of gum sandarach on the paper to make the writing crisp.

5 When you are happy with the spacing on the paste-up, measure out and rule up the paper for the cover and menu pages following this layout carefully, leaving a trim allowance all round. Write out the menu text first and leave to dry (3).

Do a trace of the lettering for the cover and transfer to the green paper (see page 37) using a white pencil – instead of a carbon pencil which will not show up on this mid-toned paper. Make sure you have enough gold gouache mixed up, then write in the flourished capitals that you have traced down, using the automatic pen. Add the white decorations when the gold is dry (4).

To complete the menu, trim out the inner pages with a scalpel and metal ruler, score and fold using a bone folder (see page 8). Trim the top and bottom edges only of the cover, score and fold, then make deckle edges as described opposite, painting the torn edges with gold gouache as a finishing touch.

Run a strip of glue down the inner edge of the inside back cover and attach the menu pages, pressing down firmly.

O To make place cards, work out a suitable size (see diagram, opposite), to accommodate initials and names at the same sizes used for the menu. Rule up and write the initials and names on layout paper (5).

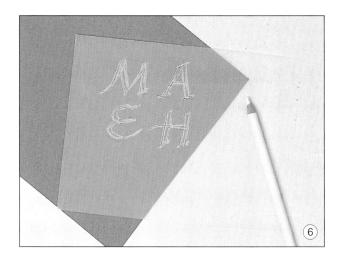

Mark the centers, cut out the elements and make a paste-up for all the cards. The capitals sit on a baseline $\frac{2}{3}$ of the capital height below the fold.

Draw out rectangles for all the place cards on the green card, rule up and transfer the initials as before (6), then do the writing in gold and white gouache (7). Pencil in trim marks around the top of the initials and cut out with a scalpel. Trim out the rest of the card, turn each one over, pencil in the halfway mark, score up to the cut edges round the capital and fold carefully right way up, making sure the top edge of the letter stands up clearly.

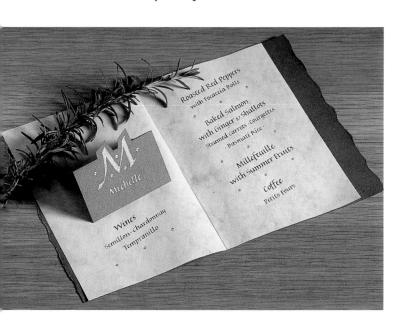

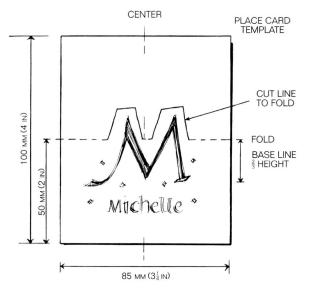

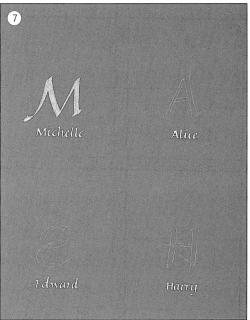

To make a "straight" edge, instead of ruling a pencil line where the deckle edge is required, score a straight line with a bone folder. For a "wavy" edge, score the line in freehand with a bone folder or the back of a scalpel blade, pressing down firmly. This helps to crush the fibers in preparation for the next stage.

Using an eye dropper or a paintbrush, trail distilled water along the crease you have made and leave it to soak in and soften the fibers for about 10 minutes (thicker papers will take longer). With the paper flat, using an even amount of pull on each side, slowly ease the crease apart sideways then leave to dry. It will dry slightly rough and cockled, rather like a true deckled edge.

making deckle edges

combining text and translation

This project, combining a Latin proverb with a translation in English in a single opening manuscript book, is a logical progression from the earlier exercises working with alphabets of different styles and weights. You could choose your own pieces in whatever languages, the principles outlined below remain the same. Here I have chosen a fairly traditional color scheme, but reversed the normal pattern and written in white on black paper, which looks quite dramatic.

specific materials

Essential equipment (see pages 8-9)

Dip pen and nibs, Nos 3 and 4

Repositionable glue

Gouache, scarlet lake, Venetian red and opaque white

Brushes and palette for mixing gouache

Text pages: 1 sheet Canson mi-teintes, 160 gsm

(110 lb text), No. 425 (black)

Cover paper: 1 sheet Canson mi-teintes, 160 gsm

(60 lb cover), No. 130 (terracotta) Interleaf: 1 sheet Thai tissue (peach)

Scalpel, cutting mat and metal ruler

Bone folder

Black embroidery thread and needle

finished size of book

open cover 205 x 220 mm (8 x $8\frac{5}{8}$ in) open tissue interleaf 195 x 190 mm ($7\frac{5}{8}$ x $7\frac{1}{2}$ in) open text pages 190 x 176 mm ($7\frac{1}{2}$ x 7 in) folds to 205 x 88 mm (8 x $3\frac{1}{2}$ in)

		versis Re bmittere i		Reb	us in adversum subm
Sp	em retíne	spes una	homin	anim	" adver
		clinquat.		Spem	um submi retine spes
≀ln a	dversity do n	ot be downcas	t!	nomin	retine spes
Kcq	up hope; hop	oe alone will no	otlea /	Cunqu	em nec mo
ever	in death		Ka	adversity o	In adve
In 2	dversity, d	lo not be do	v will	Puphope.	In Adve
	4		even	not leave a	lope alone
	8 6		2. r Spe	in death n in-retine	ווקווי

When you have chosen your original text and its translation, you will need to decide which of the two is to form the main focus of the piece. Here are some guidelines to help you put a design together.

- ☐ There should be no visual conflict between the two texts, so the eye follows each language easily, without any confusion.
- ☐ Try to link phrase with phrase to retain the sense of the words in both languages.
- If the authors' names are known, include these in the design, they may help the balance of the piece.
- ☐ Choose the calligraphic style carefully to suit the text.
- To achieve importance of one text over the other, try one or more of the following suggestions:
- ☐ Two different letter styles.
- ☐ Two different nib sizes, the same letter style (the two texts will often differ in length, a smaller nib for the longer version will shorten the lines).
- ☐ Capitals for the main text, lower case for the translation (or vice versa).
- Use two colors or two tones of one color.
- Layout possibilities are many and varied, although the length and content of your texts and the intended final form of the piece (broadsheet, manuscript book, for example) will be the deciding factors. Start by making thumbnail sketches to plan your ideas, then rule up layout paper and write out both texts in the hand and size you feel will suit the design (1).

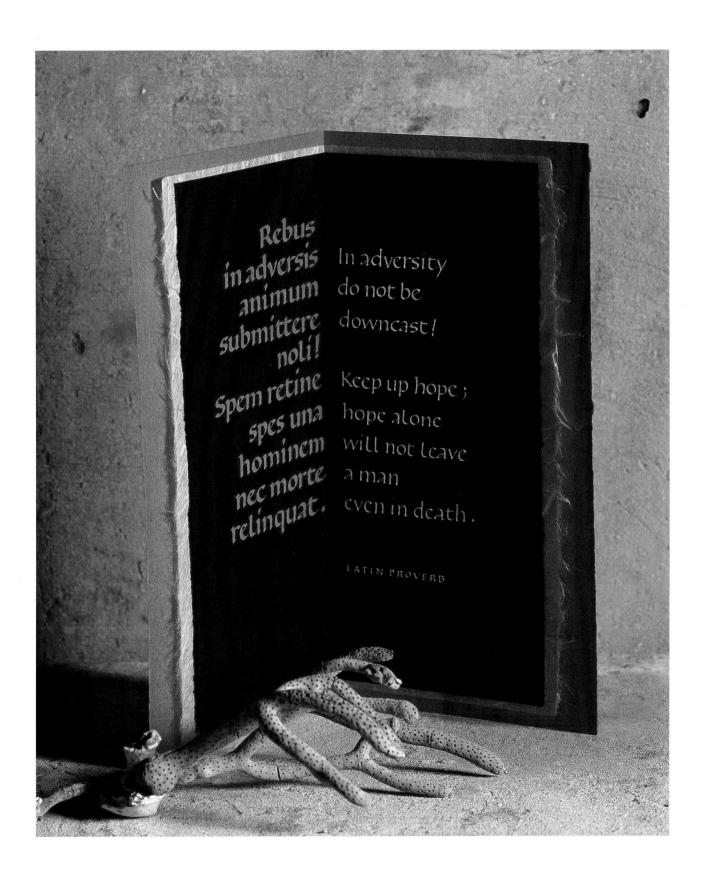

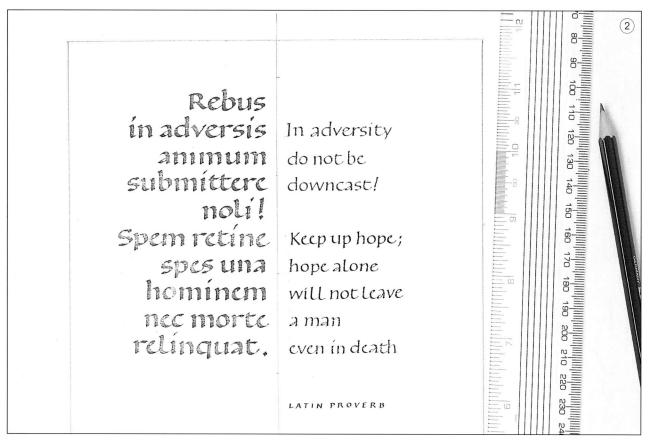

Adjust the size to weight ratio if necessary. I have used a No. 3 nib at three nib-widths x-height, foundation hand, for the Latin, to give solid weight. The translation is written in the same hand with a No. 4 nib at normal x-height of four nib-widths (the capital height is actually the same as the x-height of the Latin, which gives a sense of unity to the piece).

5 Cut out the strips of lettering (or photocopies) and try out the various permutations before making a paste-up layout. Here, I found that the line breaks worked best in a portrait rather than landscape format, keeping the sense in both languages (2). The line spacing is kept the same for both pages to help with unity; the extra line space before the attribution on the right-hand page helps balance the design. The margins of the final paste-up are based on the classic "golden section" formula: the top and outer margins are twice the gutter (margin down the center of the page); the bottom margin is twice the outer margin (see diagram).

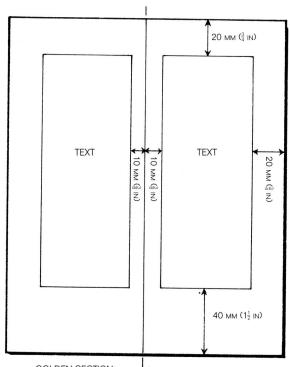

GOLDEN SECTION

Before you start the finished piece, mix up some gouache (scarlet lake, Venetian red and a little white to match the terracotta cover) and try it out to make sure it is opaque enough to be read easily on the black paper (3). The writing is done on the smooth reverse side of the paper.

in adversis animum

Rebus submittere

Recpup noli! noli

hope Spem retine

reling spes una

nec hominem

Spem do not be downcast!

abcdef LATIN PROVERB

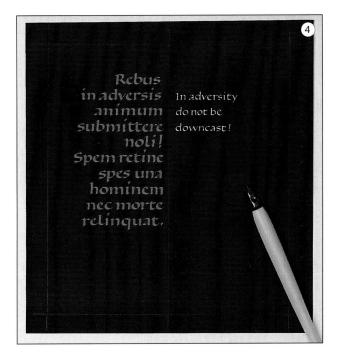

Measure out (leaving trim allowance all round) and transfer line positions onto the outer edge of the black paper. Rule up lightly so the lines are just visible, accurately following the line lengths on the final layout. This saves having to erase excess lines, which may mark the paper. Remember your pages must fold along the paper grain, not against it. Write the left-hand page first and leave to dry, then the right (4).

Measure and cut out both the cover paper and the tissue interleaf – use a scalpel and metal ruler for the top and bottom edges, but give the leading (outer) edges a deckled finish (see page 51) (5). Trim out the black text pages in the same way.

O To assemble the book, score and fold the three sections (cover, pages and interleaf) with a bone folder. The cover should have the textured surface on the outside. Mark the black pages with the position of the sewing holes along the fold (see diagram, below). Gather the pages together, hold them firmly in position on a flat surface to maintain the even margins all round (you could tack them down lightly with masking tape) and prick the holes with a needle through all three layers (5). Sew the book following the diagram, finishing with a neatly tied reef knot in the center. Snip off excess thread with scissors.

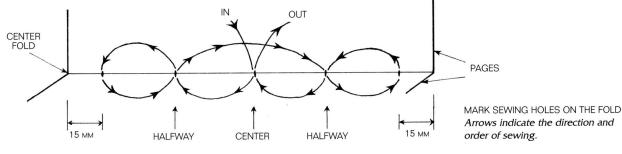

multilingual lendar

This multilingual calendar is a complex project to put together, but offers plenty of scope for creative calligraphic ideas. It involves experimentation with size and weight of drawn and painted letterforms, the use of both colored and textured papers, as well as sorting out some tricky design problems.

I wanted to produce a finished piece that had an appropriate seasonal feel, with numbers easily visible when the calendar was hung up. I decided to break the year down into the four seasons and chose appropriately colored and interestingly textured papers to reflect this scheme. I wanted the calligraphic designs to be based on pen-written, or drawn and painted letters with minimal or no decoration, which would in some way symbolize the month and season.

papers

Season Base papers (handmade)

~ Month overlays

Winter Khadi neutral

- ~ Canson mi-teintes, 160 gsm (60 lb cover), blue Spring Khadi algae (green threads)
- ~ Ingres, 160 gsm (60 lb cover), yellow-green Summer Khadi marigold (yellow petals)
- ~ Canson mi-teintes, 160 gsm (60 lb cover), orange Autumn Khadi straw (dried grass stems)
 - ~ Ingres, 160 gsm (60 lb cover), rusty-brown

other materials

Essential equipment (see pages 8-9)

Dip pen and nibs, Nos $1\frac{1}{2}$ and 5

Repositionable glue

Colored pencils, basic range

Gouache, from basic range, colors to tone with month overlay paper

Brushes and palette for mixing gouache

- 2 sheets each of Khadi papers (see left), allows for color trials and possible errors
- 1 sheet each of colored papers (see left), allows for color trials and possible errors

Double hole puncher

Neutral embroidery thread

Piece of bamboo cane

finished size of calendar 227 x 385 mm $(8\frac{3}{4} \times 15\frac{1}{8} \text{ in})$ with month overlays 227 x 122 mm $(8\frac{3}{4} \times 5\frac{3}{4} \text{ in})$

1 Start by making thumbnail sketches of the basic design of the base pages. Use the size of the base paper and how it can be divided economically to help you decide on proportion and format. The Khadi papers will cut into four good-sized pieces; three for finished pages and one spare for practice. These papers are handmade and have wonderful deckle edges, so, rather than lose the character of the material when you cut the pages out for ruling up, use the deckle method (see page 51).

Write out the days on layout paper in five languages and the dates at the letter heights you think will suit. The numbers need to be fairly bold for ease of legibility

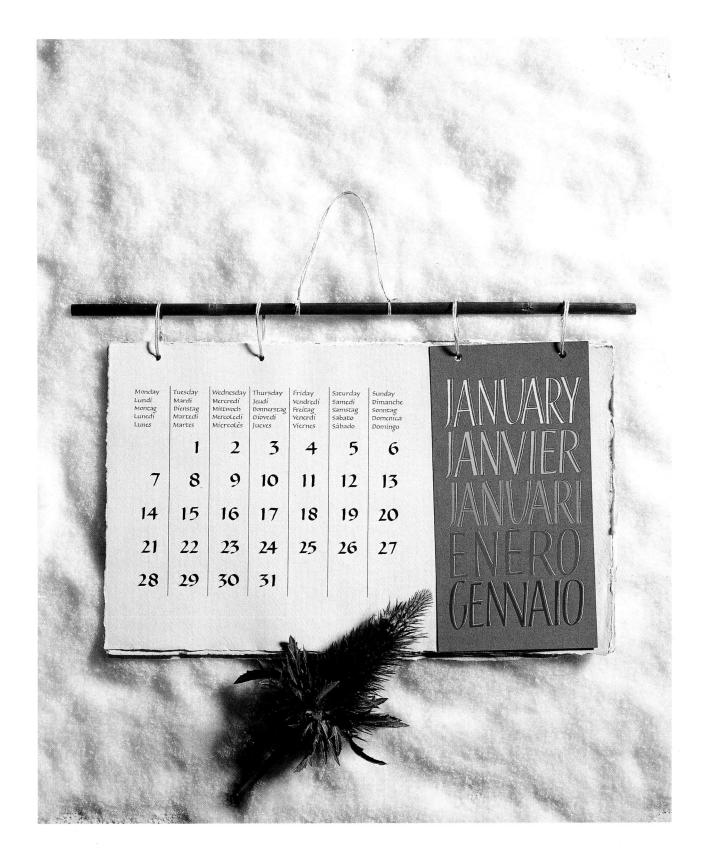

(written with a No. $1\frac{1}{2}$ nib), the days smaller and lighter in weight so that they will fit into fairly narrow columns (written with a No. 5 nib).

3 Cut all the elements or photocopies into strips. Draw up a rectangle on layout paper corresponding to the final paper size. Work out and draw in the column widths, then make a paste-up of the whole page. You may need to alter letter and/or number sizes to fit. Consider the use of a second color to enhance the design.

Work up some ideas for the month overlays from small sketches to same-size layouts – I like to do these on tracing paper, laying one on top of the other, refining the lettering at each stage. Start to get some idea of how you will use color on these overlays. Photocopy the trace layouts onto plain paper and fill them in with colored pencils to help you experiment. Here are some of the styles of lettering and coloring that I used:

- ☐ January (1): Long thin letters look like icicles or snow on snow. Graduated shades of blue are used with monoline white "shadows".
- April (2): Strands of spiky letters wave upwards like growing plants, in spring yellows and greens. Flecks of red give a touch of vibrancy.
- August (3): Hot summer shades of red move out to white on a bright background, like a blazing sun. Dots of the complementary color, cobalt, are added as punctuation.
- October (2): Mellow shades of autumn are used and the letters are piled up like fallen leaves.

The designs for the months in between could carry on the "flavor" set by these ideas. Decoration, if any, is restricted to tiny flashes of complementary colors. 5 All the lettering should be drawn, then painted. Do paint and ink trials on spare pieces of all the papers before you begin the preparations for the finished work. Use the smooth side of the colored papers (4).

The simplest way to mark up all the base pages uniformly is to make a paper template on which you indicate the position of everything. Transfer these marks lightly onto each sheet and rule up ready to write. To avoid too much bulk on one side of the calendar, the position of the month overlays alternates from the right- to the left-hand side, so make allowance for this on the template.

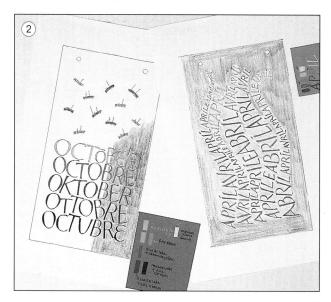

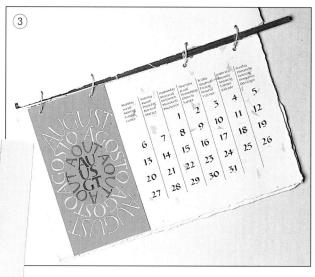

	(1 0			
uesday lardi ienstag artedi artes	Mittwoci Mercoled Miercoles	Donnersta	I want is	Saturday Samedi Samstag Sabato Sabado	Sunday Dimanche Sonncag Domenica Domingo
1	2	3	4	5	6
8	9	10	11	12	13
5	16	17	18	19	20
2	23	24	25	26	27
9	30	31			

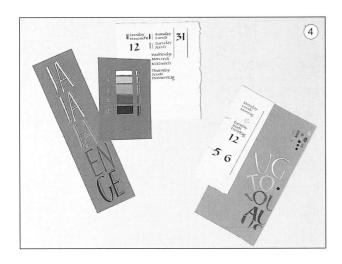

Monday Lundi Montag Luncdi Luncs	Mardí Dienstag Martedí Martes	Wednesday Mercredi Mittwoch Mercoledi Micreoles	Thursday Jeudi Donnerstag Giovedi Jueves	Friday Vendredi Freitag Venerdi Viernes	Saturday Sainedí Sainstag Sabato Sabado	Sunday Dimanche Sonntag Dominica Domingo
	1	2	3	4	5	6
7	8	.9	10	11	12	13
14	15	16				

Write the days and put in the dividing rules in the color for each month first, then the numbers in black ink (5). Organize the work to suit yourself; you may prefer to do one base and overlay at a time and see some progress, rather than spending ages just on ruling up.

When you have completed all the bases and overlays, think about a design for the cover and sketch out some ideas. My solution was to cut out strips of the four colored papers and stick them onto a sheet of the neutral Khadi paper with large black numerals between (6).

O The binding should be simple and practical so that pages can be turned easily. Devise a method of marking the pages, so you know where to position the punch correctly each time and do trials on scrap paper. One pair of holes should be centered over the overlays at each side. Punch the pages, then put together with loops of embroidery thread, tied with reef knots. Cut a length of slim bamboo cane slightly wider than the calendar pages, slip this through the thread loops and add a separate thread for hanging, knotting it tightly onto the cane midway between the pairs of holes.

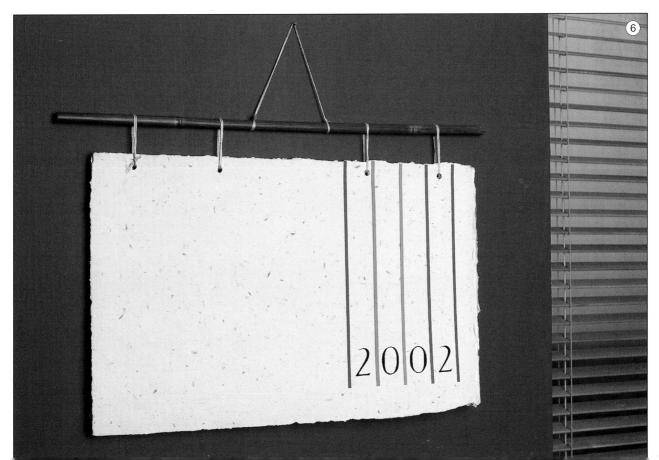

pushing out the boundaries

Most of the techniques and projects you have tackled so far have been fairly conservative in their treatment of letterforms, enabling you to learn the principles of calligraphy and understand them first. With that knowledge under your belt, now is the time to push out the boundaries and explore some exciting new possibilities. Try using unusual tools to write with, see how much you can stretch or compress letterforms before legibility is lost, find out about new techniques to extend your repertoire. Have fun!

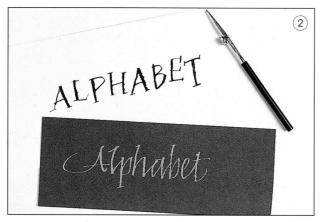

new tools

The following tools, both commercial and homemade, can be used with paints and inks to create exciting new effects.

CARD PENS: Cut some 1 mm $(\frac{1}{32}$ in) thick card into strips of different widths and dip these into colored inks to use as you would a normal dip pen (1). Hold the "nib" end at the appropriate angle and try copying the examples (see pages 24–31). You can make very big pens in this way, and strips of wood veneer or chunks of thick felt held in a bulldog clip are effective alternatives. You will need to pour out your ink or mix paint in palettes or saucers that are large enough to accommodate these big pens.

RULING PENS: These are usually used to draw fine, even lines, but they also make effective writing tools (2). The narrower type need to be held on their side to make broad lines. Try pearly or metallic inks on dark paper or bright acrylics on rough watercolor paper. Don't worry about the splatters you make, they can be incorporated into the design.

ROUGH STRING: Rough, garden twine can be a little unpredictable for writing or drawing with, but it can also produce some very interesting and decorative effects that can be exploited for modern designs (3). Bind a piece of string around the middle with masking tape. Dip into paint or ink and use it as you would a normal pen.

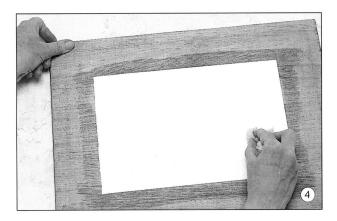

5

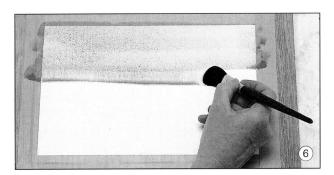

new backgrounds

There are a number of simple techniques you can employ to make interesting backgrounds for your calligraphy projects.

STRETCHING THE PAPER: Before you can lay a painted watercolor background, the paper has to be stretched to prevent it cockling as it dries. Immerse the paper in a tray of cold water, or hold it under running water, making sure both sides are evenly wet. Drain off excess water and lay the sheet carefully onto a clean, plywood drawing board which is larger than the paper. Blot the surface with a dry sponge, but do not "scrub" at the paper or the surface will be spoilt (4).

Cut four strips of gummed paper tape (one for each side of the paper). Damp one strip at a time with a wet sponge and use it to stick the damp watercolor paper to the board, allowing a 10 mm ($\frac{3}{8}$ in) overlap onto the paper. When all the sides have been taped down, lay the board flat and allow to dry out completely (5).

TEXTURED BACKGROUND: To make a textured background, stretch the paper as described above and leave it on the board. Lay a wash of watercolor paint, well diluted, over the paper with a wide, soft brush (6). While the paint is still wet, lay a piece of transparent food wrap (cling film) over it, and pull the food wrap together slightly (7). Leave it to dry flat. Remove the food wrap to reveal a rather interesting, batik-type finish, over which you can write with gouache or ink.

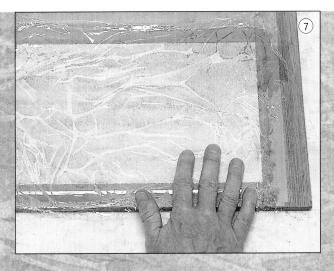

PASTEL BACKGROUND: To make a soft and subtle background "wash", scrape a pastel stick with a knife onto a smooth or slightly textured paper (8). Rub the resulting powder into the surface with cotton wool (9). Experiment with blending colors. You may need to seal the pastel with a light spray of fixative before writing over it either with gouache or ink.

OIL PASTEL BACKGROUND: Scribble with an oil pastel onto a piece of cartridge or smooth watercolor paper to create a thick, even layer, blending the colors (if more than one is used) with your fingers (10). Letters or designs can be scratched into the oil pastel using the point of a scalpel blade or an old broad-edged nib (11).

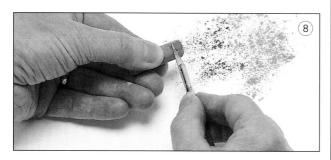

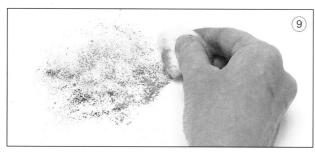

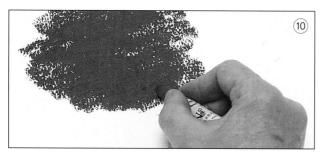

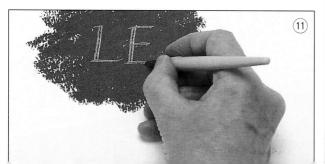

resists

Masking fluid is used in watercolor painting as a resist to block out the paint. In calligraphy we can use it to write or draw a motif that will not absorb a subsequent wash or paint. Gouache resist works in a similar way, but the writing is done with white gouache and waterproof inks are used for the color overlays.

MASKING FLUID: You can write with masking fluid using broad-edged nibs, as well as with a brush: use an old, or synthetic brush for this. Both nib and brush will need a good wash out with warm, soapy water after use. Write without a reservoir on the nib, draw or paint a design with the masking fluid onto paper of a reasonable weight (12). Allow to dry (it will have a matt appearance).

Mix up some paint and apply a colorwash to the paper. You can add other toning or contrasting colors when the first wash is still wet, allowing the colors to mingle (13). Leave to dry out completely.

Gently rub off the rubber solution with your fingers, using a circular motion, to reveal white letters out of a colored ground (14 and 15). Don't rub too hard or the paper surface will be damaged. Try experimenting with multilayers of resist and color.

GOUACHE: Paper of about 300 gsm (140 lb) is best for this technique, as it will stand up to the robust treatment and is less likely to cockle as it dries. Write or draw out a design, using white gouache (tinted with a touch of yellow ochre to make it visible on white paper) and allow to dry hard (16). Use a hairdryer to speed this up.

Brush colored waterproof ink quickly over the design, dropping in other colors if you wish. Leave to dry completely, then immerse in a bath of tepid water (17). Soak until the gouache begins to dissolve – it should float off, but can be "assisted" with a sponge or brush (18). Leave to dry spread out on a flat surface (19).

On rough watercolor paper this technique gives interesting effects, especially if the letters are written with chisel-edged oil painting brushes. Paint laid thickly gives the best resist. The inks will penetrate through thinner paint giving a pale-toned result, which could be exploited in your design. Experiment with extra layers of resist and different combinations of colors. Make notes as you go, so that the effects can be repeated.

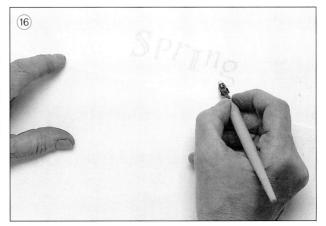

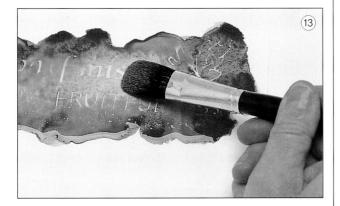

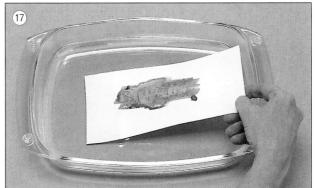

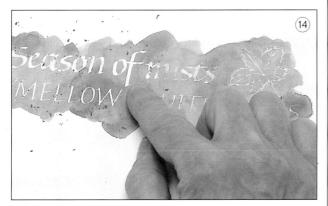

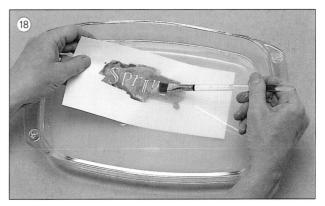

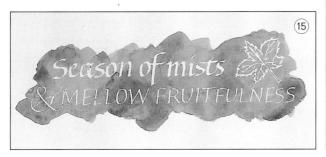

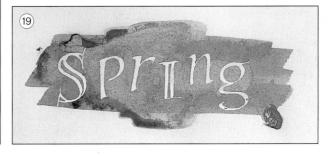

gilding

Flat gilding with transfer gold leaf is not very difficult and it will add a really luxurious shine to your work. You can gild onto most papers, although tissue paper is too thin.

For this technique you will need

Gum ammoniac solution or PVA glue mixed 50/50 with distilled water Dip pen or synthetic brush to apply the size

Transfer gold leaf

Burnisher (or use the flat end of a bone folder – but not on the gold leaf)

Piece of plate glass (edges rounded)

Glassine (crystal parchment)

Soft paintbrush

Soft, clean silk

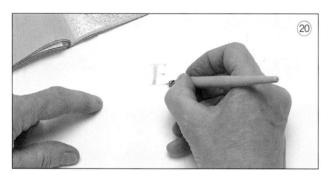

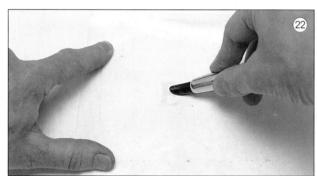

With your drawing board flat, apply the gum ammoniac or PVA solution to the paper with a dip pen (without the reservoir attached) or a brush and leave to dry for about 30 minutes (20). Breathe onto the size, three or four good, deep breaths, to make it tacky. Quickly lay a sheet of transfer gold leaf over the size and press it down firmly with your fingertips, taking care not to twist it. Rub down gently with a burnisher or bone folder, then peel back the paper to check if the gold has adhered (21). If it has not, repeat the breathing and application

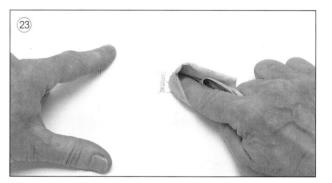

process until all the size is covered. You will need to apply at least two complete layers of gold.

Lay the work on a sheet of glass, with a piece of glassine over the gilded area. Gently burnish through the glassine (22). The hard surface beneath the work gives a better burnish than the drawing board. Remove the glassine and dust away surplus gold from around the edges of the letter with a soft brush. Polish with soft silk (23).

Patterns or dots can be indented into the surface of the gold leaf using a hard pencil through glassine.

christmas

ALLELUIA

Here's another greetings card to make, this time a seasonal offering created with rough string and gold leaf.

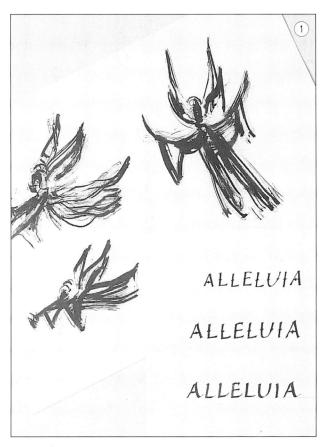

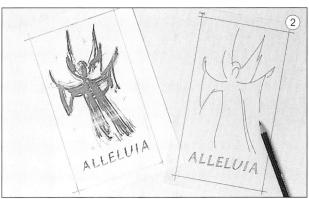

specific materials

Essential equipment (see pages 8–9)

Rough string

Dip pen and nib, No. 3½

Repositionable glue

1 sheet of Canson mi-teintes, 160 gsm
(60 lb cover), No. 500 (dark blue)

PVA glue mixed 50/50 with distilled water, tinted with a little red gouache so it is visible on the paper Gilding equipment (see page 64)

White pencil for transferring design

Gouache, opaque white

Brush and palette for mixing gouache

Scalpel, cutting mat and metal ruler

Bone folder

finished size of card 185 x 105 mm ($7\frac{3}{8}$ x $4\frac{1}{8}$ in) when folded

Do some thumbnail sketches to clarify your ideas, then start experimenting, drawing out angel shapes on layout paper at approximately finished size. Cut a length of rough string and bind it round the middle with masking tape to make it easy to hold. Dip the rough string "brush" into black ink and use it to draw the angel. This sort of technique is best reserved for fairly large-scale work requiring loose, gestural drawings. It is quite difficult to reproduce exactly the same image twice, as the string is not a precise tool. Use the dip pen to write out the wording, trying different sizes, styles and weights to find the best balance with the angel. Plain letters are best as they contrast well with the vigor of the drawing (1).

Make a paste-up of the image and lettering (2) – the drawing you choose will dictate whether your card is to be horizontal or vertical in format – and decide the margins using card strips. Modifications can be made at

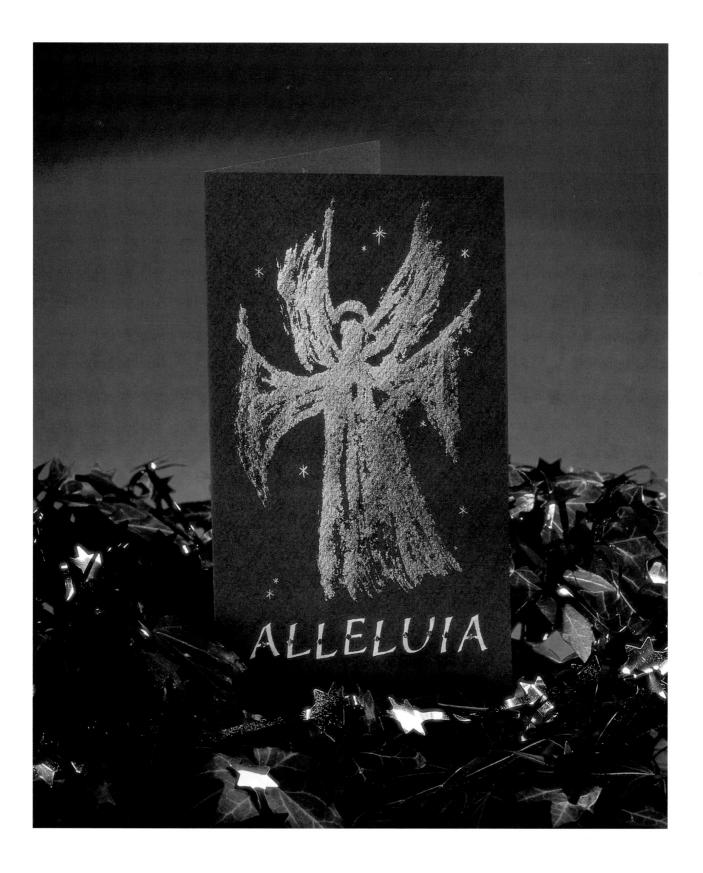

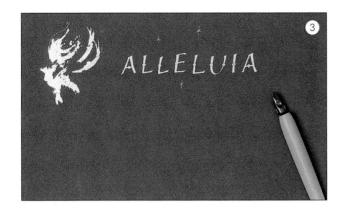

this stage. I decide to let the letters "bounce" rather than write them on a straight line, to enhance the feeling of movement, and add a few little stars to the background.

3 Try out the gilding technique (see page 64) on the blue paper, applying the size as the lettering with a dip pen without a reservoir (3). You may need to add a little more PVA to the size mixture if the gold does not stick well first time. Apply the PVA mix to the angel shape with a clean piece of string, as close as possible to your original design: put on plenty of the medium and draw out of it to make fine lines. Gild as usual.

Draw out the rectangle for the card (185 x 210 mm/ $7\frac{3}{8}$ x $8\frac{1}{4}$ in full size) with trim allowance all round. Trace the design and wording and transfer it to the blue paper using a white pencil (4) (see page 36).

Gild the angel as practiced in Step 3 (5). Using opaque white gouache, write in the lettering with the dip pen. When it is dry, paint in the little diamonds on the letter stems with PVA size and gild them as before. If the gold leaf adheres to the paint, use a pointed scalpel blade to scrape it off gently and go over the letters again with a No. 000 sable brush to tidy them up if necessary.

Add one or two tiny white stars in the background, as on your rough design. Give the gold leaf a final polish with the soft silk, then trim out the rectangle. Mark the center on the reverse side then score and fold with a bone folder. To remove any excess white pencil marks, use a slice of eraser cut off with a scalpel. This not only gives a sharp edge, but makes it more manoeuvrable in awkward corners.

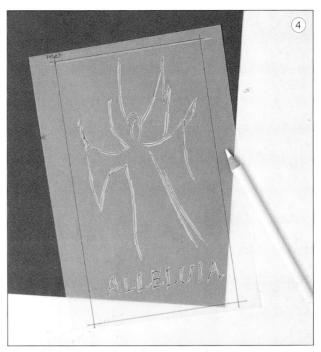

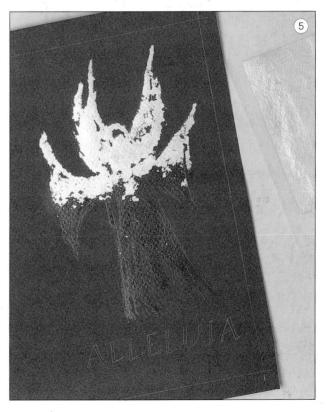

Make a matching envelope, adapting the basic template on page 47.

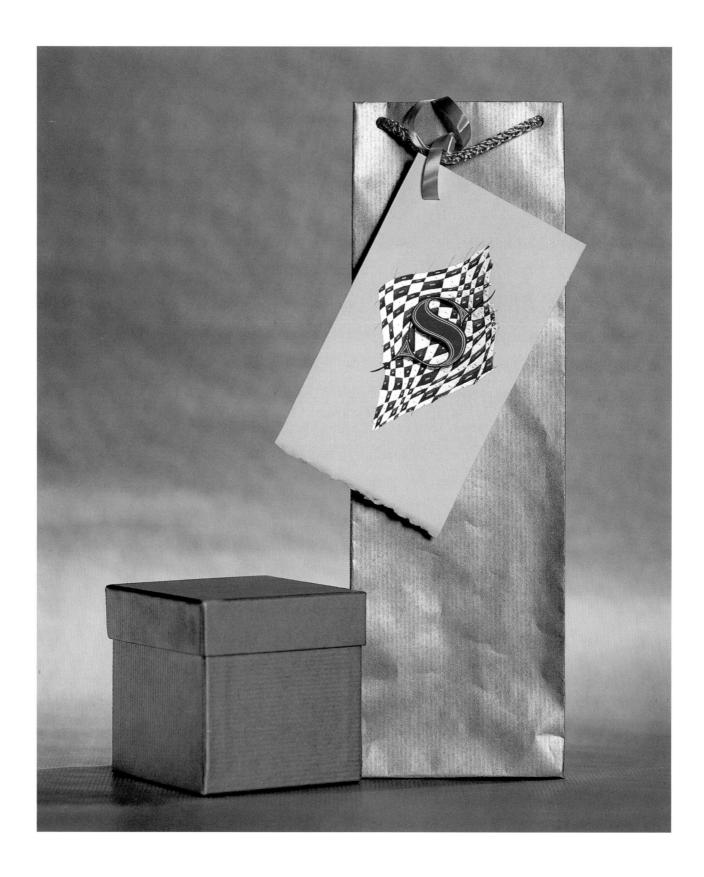

gilded and letter

Here is a traditional idea taken from old manuscripts and given a modern flavor, using gold leaf on gum ammoniac to make an attractive framed piece, or used as a gift tag. I have chosen a Lombardic style versal letter (see page 31) for my model here. These letters have voluptuous curves, which lend themselves to decoration, and the serifs can also be extended to add to the decorative possibilities. Choose the appropriate letter for the name of the recipient of the gift.

specific materials
Essential equipment (see pages 8–9)
Dip pen and fine pointed drawing nib
Gouache, French ultramarine, scarlet lake,
cadmium yellow, opaque white and black
Colored pencils, in similar shades to gouache
1 sheet Hot Press watercolor paper, 300 gsm (140 lb)
Waterproof black ink, well diluted
Gum ammoniac solution
Synthetic brush, No. 0
Scalpel, cutting mat and metal ruler
Brushes and palette for mixing gouache
Sable brushes, Nos 3, 0, 00 and 000
Ballpoint pen

finished size of letter and background $70 \times 65 \text{ mm} (2\frac{3}{4} \times 2\frac{1}{2} \text{ in})$

1 Draft out your chosen letter shape on layout paper at actual size, then consider the scale of the background diamond pattern and draw this out too (1). I have chosen to twist the pattern as though it were folded fabric, which produces some interesting shapes.

2 Use colored pencils to fill in the pattern to see how the shapes work. Trace the letter shape and lay this over the colored pattern, moving the trace around until you find an area that looks good behind the letter (2). You may have to make some adjustments to the twisted pattern to get it just right. Use card strips to decide the margins around the letter and mark them on your tracing.

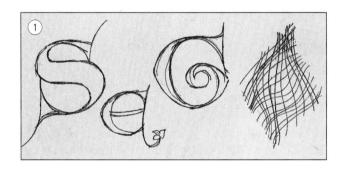

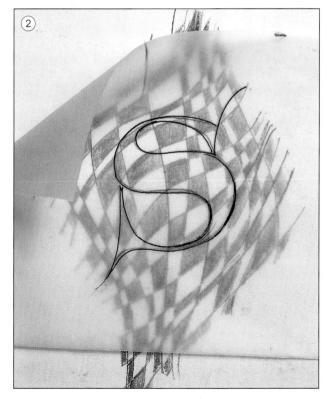

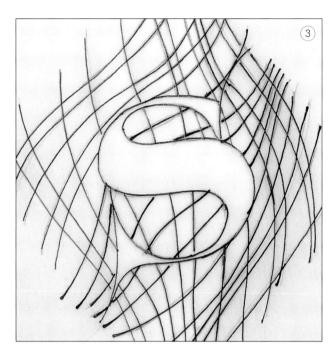

When you are satisfied that the design hangs together well, go over letter and background pattern onto a fresh sheet of tracing paper (3), then transfer it to watercolor paper (see page 36), allowing plenty of space all round for margins.

4 Go over the traced lines with very well diluted waterproof ink and a pointed nib, erasing any visible pencil lines carefully when the ink is dry. When you paint over the lines, ink will not repel or mix with the paint as pencil carbon would.

5 Do the gilding first. Stir the gum ammoniac solution thoroughly, then, following your color sketch and using a No. 0 synthetic brush, lay an even layer over the appropriate areas. Try to avoid getting bubbles when laying the gum and allow it to dry for about 30 minutes. Apply two layers of gold leaf as described on page 64, making sure that all the gum is completely covered (4). Burnish gently between applications through glassine.

Clean off surplus gold with a soft brush and tidy up any rough edges with a pointed scalpel blade before polishing with a piece of soft silk. Mix up some French ultramarine and paint in the remaining diamonds, using a No. 0 or 00 sable brush as appropriate (5).

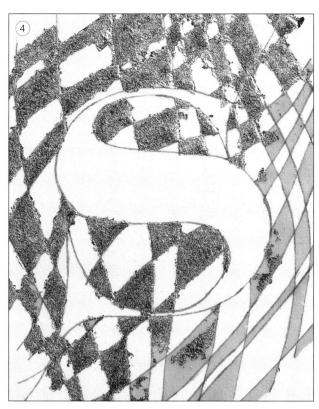

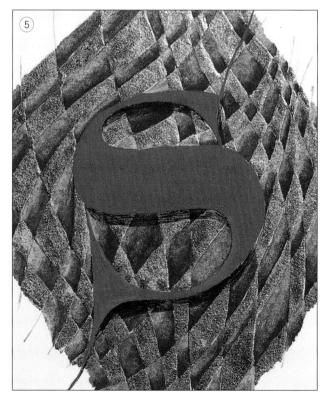

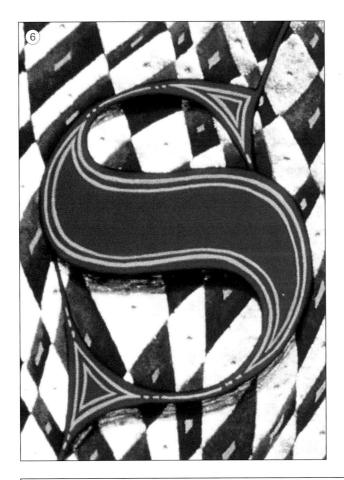

Draw in the outline of the letter using a No. 00 sable brush and a mixture of scarlet lake plus a little cadmium yellow. Use this fine brush to fill in the narrow parts of the letter, but switch to a No. 3 for the rest, painting in generous sweeps (5). Keep the color moving and add more paint to the brush as necessary. If you paint wet into wet, you should get a nice even layer of color.

Mix black gouache with a little French ultramarine igcup and paint an outline around the letter with a No. 000 brush. A very steady hand is required, although any tiny wobbles can be painted over, if necessary. With the same brush and color, paint in fine, hairline strokes to form a "shadow" beneath the letter, then blend these strokes together with a dampened No. 3 brush.

Add highlights with opaque white, a No. 000 sable brush and the steady hand already mentioned. Indent dots in the center of each gold diamond with a ballpoint pen through a piece of glassine, to add an extra twinkle (6). Use a craft knife or hole punch to make a slit/hole for the ribbon in the top corner. If you want to frame the finished piece, cut a bevel-edged mount according to the margins you chose in step 2, which keeps the gold from coming into contact with the glass of the frame.

or the project, the letter was kept fairly plain as it sits on a busy background of blue and gold diamonds. An alternative could be a rather more elaborately decorated letter on a plain gilded background, created in the same way: gilding first, then paint the letter, and finally add the outline and white decorations.

For the dotted lines over the gold, work out the pattern on the original tracing first. Cover the work with glassine, lay tracing over this and tack down with masking tape. Follow the tracing and transfer the dotted lines using a ballpoint against a ruler to keep the lines straight, pressing quite hard to make a reasonable impression through the two layers onto the gold. Draw in small diamonds freehand within the dotted shapes.

The flourished "tails" are drawn in last of all, with gouache in a fine pointed nib. Practice the flourishes on paper first, then draw them straight onto the work freehand. Tracing them down first is unsatisfactory as the results often

look stiff. Just have courage

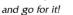

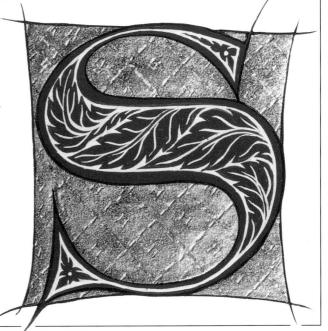

variation

alphabet and a-z

This project develops your early experiments with combining alphabets and flourished italics and adds a gold focal point, which is written with a card "pen". When framed it will make an attractive piece.

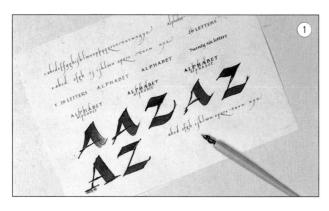

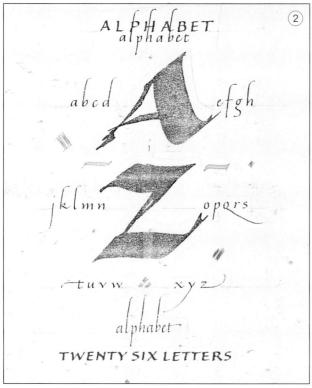

specific materials Essential equipment (see pages 8-9) Dip pen and nibs, Nos $3\frac{1}{2}$ and 5 Repositionable glue Gum ammoniac solution Colored pencils, black, red and gold 1 sheet Ingres paper, 160 gsm (43 lb), black Gouache, scarlet lake Schmincke Tro-col bronze (pale gold, powdered gouache) Brushes and palette for mixing gouache Scrap card, to use as a "pen" Gilding equipment (see page 64) White pencil (optional) Scalpel, cutting mat and metal ruler Acid-free card, 1 mm $\binom{1}{32}$ in) thick Bone folder

finished size overall 260 x 190 mm $(10\frac{1}{4} \times 7\frac{1}{2} \text{ in})$

size of cut out 175 x 110 mm ($8\frac{7}{8}$ x $4\frac{3}{8}$ in)

1 Do some thumbnail sketches and then write out the various elements of the piece in black ink on layout paper, experimenting with nib and letter sizes and weights (1).

Make one or more paste-up layouts of promising designs (use photocopies so you won't need to write things out more than once), deciding the margins with the help of card strips. Redraw your chosen layout (2).

Photocopy your layout (or work on the original if you prefer) and use colored pencils to get an idea of the color balance and where you could perhaps add a flourish or two to complete the design (3).

Do some trials on a small piece of black Ingres paper (using the laid surface) (4). Use a pen to write the words in gum ammoniac. To give a little twinkle to the scarlet gouache, drop in a very small amount of Tro-col powder as you mix it, stirring each time you load your nib. The laid texture which gives an interesting effect with the large gold letters will cause some problems when writing with a fine nib. You can flatten the laid lines with a bone folder, although this makes the paper shiny. Either accept a few imprecise lines and tidy them up, using a scalpel for the gilding or a fine brush for the red letters, or use the smooth side of the paper.

5 Use a card "pen" (see page 60) to practice writing in the large A and Z with gum ammoniac. Before the gum solution dries out, scrape a line (straight, wavy or zigzag) into it with a paintbrush handle and leave to dry completely. Gild the words and the A and Z as usual (see page 64).

Oraw out the rectangle (with trim allowance) on the black paper and rule it up lightly.

Follow the line lengths on the paste-up accurately to minimize the amount of erasing necessary. You may wish to use the carbon method (see page 36) with a white pencil to transfer the letters to be gilded.

7 Gild the letters as practiced in Step 4.

Mix up some fresh red gouache and Tro-col powder and write in the remaining parts of the design (5). You

will have found from your experiments that the gold powder gives an interesting speckled finish. To make the most of this effect, write only about two letters at a time, rinse the nib,

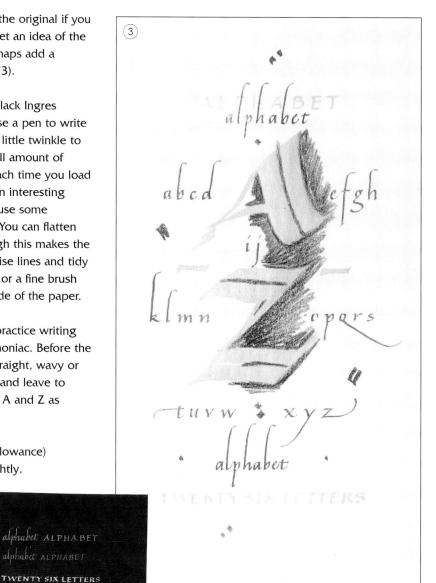

remix the paint, reapply to the nib and carry on in this way until you have finished. It may seem a little laborious, but without this extra effort, the letters will end up plain red.

Trim out the piece with a scalpel and metal ruler, then draw out and cut a rectangle of the same size from acid-free card. Attach the finished piece to the card rectangle with a dab of glue at each corner.

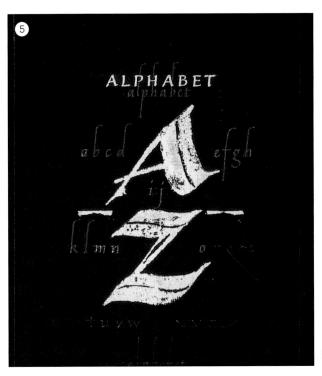

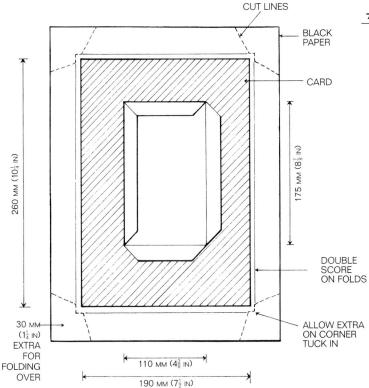

to make a paper-covered mount

Use another sheet of card and Ingres paper to make a mount. Cut out a rectangle of card as large as your frame. Draw up and cut out a window in the card, to correspond with the position of the image. Top and side margins should be the same, the bottom one slightly deeper.

2 Cut a rectangle of Ingres paper, about 30 mm ($1\frac{1}{4}$ in) larger all round than the card, making sure the laid lines go in the same direction as on the finished piece. You will also need to cut a narrow strip, 1 mm ($\frac{1}{32}$ in) wide, pieces of which should be stuck into the corners of the window to eliminate any white showing when the flaps are folded round.

Braw out a rectangle the size of the item being framed (here, 260 x 190 mm/ $10\frac{1}{4}$ x $7\frac{1}{2}$ in) on the reverse side of the black paper and another rectangle 1 mm ($\frac{1}{52}$ in) larger all round, then score them both – this allows the paper to be folded easily over the thickness of the card (6). Repeat the process for the hole in the middle.

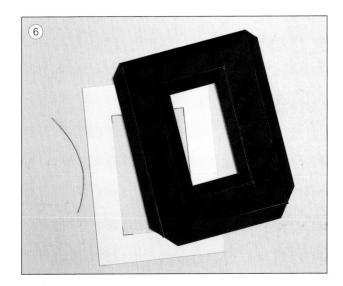

Put dabs of glue in the card mount corners and stick it down onto the back of the black paper, matching corner marks.

5 Follow the diagram (above) for cutting inner mitres and outer corners. With clean scrap paper underneath, glue each flap and smooth down onto the mount, tucking in the outer corners with a bone folder.

a magic carpet: gliding with color

This simple technique, using colored size under gold leaf, which is etched back to reveal the colors, yields interesting results which make attractive presents. I have based my design on Oriental carpets, but there are many other possibilities.

specific materials
Essential equipment (see pages 8–9)

1 sheet Hot Press watercolor paper, 300 gsm (140 lb)
Gouache, dark but bright colors that show
 up well against gold, for example scarlet lake,
 French ultramarine and viridian
PVA glue
Distilled water
Gum ammoniac solution
Synthetic brushes and palette for mixing colored gesso
Gilding equipment (see page 64)
6H pencil
Scalpel

finished size $30 \times 74 \text{ mm} \left(1\frac{1}{8} \times 1\frac{3}{4} \text{ in}\right)$

Devise a pattern to scratch into a gilded surface to reveal the color beneath, sketching your ideas out on tracing paper at full size. Designs can be quickly modified by laying over another sheet and tracing off; you also have the design ready to transfer onto the gilding (1).

2 Transfer the outline of your design to watercolor paper (see page 36).

Make a colored gesso by squeezing out about $6 \text{ mm } (\frac{1}{4} \text{ in})$ of gouache and combining it with 4 drops of PVA mixed 50/50 with distilled water, 4 drops of gum ammoniac mixed 50/50 with distilled water, and 4 drops of undiluted PVA glue. Use the end of a paintbrush to measure out the drops, and aim to keep them all roughly the same size. Mix to a smooth, stiff consistency, repeating the formula for each color you want to use in separate palette wells. It is possible to keep this gesso from drying out too quickly by covering the palette tightly with plastic food wrap (cling film).

4 Use a synthetic brush to apply the colored gesso. First experiment on scrap paper with alternating stripes, squares of different sizes and other motifs.

Then paint your chosen design on watercolor paper.

There's no need to be too precise, so draw the shapes in freehand. Aim to apply an even, flat layer: this is quite difficult as the mixture is rather sticky, but try to avoid getting too many lumps and bubbles. Cover the full design area with color and add the "tassels" with gum ammoniac and then leave to dry completely (2).

5 Cover the entire colored area with at least two layers of transfer gold leaf (see page 64) (3). Burnish well through glassine.

6 Lay your tracing over the gold surface and go over the design lines using firm pressure with a 6H pencil. Don't be too precise, just transfer the bones of your layout and let the design evolve as you work through step 7.

Remove the tracing paper and scratch the pattern into the gold with a scalpel to reveal the color, but not so hard that you go through to the paper (4).

When you have completed the scratched design, clean off the surplus color and gold with a soft brush and then polish the gold gently with a piece of soft silk. If framing behind glass the piece should be mounted to keep the gold away from the glass.

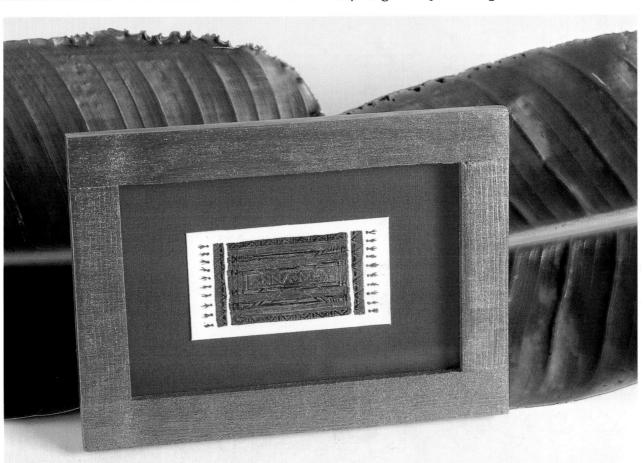

glossary

ARMENIAN BOLE Red-brown earth pigment.

ASCENDER Part of the lower case letter extending above the x-height.

BASELINE Line on which letters are written.

BLEED Occurs when the paper surface absorbs ink or paint.

BODY HEIGHT Main part of the letter, also known as the x-height.

BONE FOLDER Flat piece of bone, round at one end, pointed at the other. Used for scoring and folding paper.

BROAD-EDGED NIB Produces thick and thin strokes by writing at a constant angle, not by pressure.

BURNISH To polish gold leaf to a glossy finish, usually through glassine to protect the leaf.

BURNISHER Tool used to burnish gold leaf. Can be made of agate, haematite or psilomelanite.

CAPITAL Majuscule or uppercase letter.

COMPLEMENTARY COLOR Each primary color has a complementary color made by mixing the other two primaries.

DESCENDER Part of the lower case letter extending below the baseline.

EXEMPLAR A model alphabet or piece of work for students to study.

FORM Abbreviation of letterform, meaning the actual shape of the letter.

GESSO A mixture or solution laid as a base for gilding.

GLASSINE Transparent, non-stick paper used to protect work in progress, as an overlay for finished work and in gilding.

GOUACHE Opaque water-based paint, also known as body color.

GRAIN In paper, direction in which most of the fibers lie.

GUM AMMONIAC Plant resin. Can be soaked in water to make size for gilding. Also available as a readymixed solution.

GUM ARABIC Plant resin. A drop or two of the solution added to paint helps it flow and gives a slight sheen to the paint when dry. If there is little gum in the tube of paint, it will not adhere properly to the paper.

GUM SANDARACH Plant resin. Ground fine and applied to paper, it is a water repellent. Useful on absorbent paper to prevent bleed.

HAND Another way of describing a letter style, for example, the italic hand.

INTERLINEAR SPACE Space between two lines of writing, usually measured by the x-height.

LAYOUT Arrangement of heading, text, illustration and any other elements in a piece of work.

LETTERFORM Actual shape of the letter.

LIGATURE Linking strokes between letters.

LOWER CASE Typographical term for small letters or minuscules.

MAJUSCULES Capital or uppercase letter.

MINUSCULES Small or lower case letters that have ascenders and descenders.

MONOLINE Letters made with strokes of a single nib-width or drawn with single pencil lines, also called skeleton letters. The essence of the letterform.

OX GALL In liquid form, add sparingly to mixed paint to improve flow from pen or brush.

PASTE-UP Assembled cut-up elements of a piece of work are stuck onto paper to finalize the layout.

PEN ANGLE Angle at which the pen meets the paper in relation to the writing line.

Pounce Powdered pumice, used to remove grease from paper.

PVA Polyvinylacetate, a glue.

SERIF Stroke that leads into or finishes a letter.

SHADE OF A COLOR Made by adding black in graded amounts to any given color.

SIZE Glue added to paper pulp or applied to the surface of a finished sheet to make it less absorbent to ink or paint. Also a sticky base to which gold leaf will adhere.

SKELETON LETTER Letter made without the calligraphic weight of a broad-edged nib. Also known as monoline.

STEM Main vertical stroke of a letter.

STROKE Component of a letter made without lifting the pen from the writing surface.

TONE OR TONAL VALUE Gradation from light to dark, visible in any solid object viewed in the light. Best seen by half-closing the eyes.

TOOTH Very slight surface texture of paper, which prevents the nib from slipping.

UPPERCASE Typographic term for capital letters or majuscules.

WEIGHT Relationship of the nib-width to the height of a letter.

WET-AND-DRY PAPER Abrasive paper available in several grades. The finer grades are useful for nib sharpening. Available from DIY stores or motor accessory shops.

x-HEIGHT Main part or body height of the letter, not including the ascender or descender.

usefuladdresses

Artpaper.com c/o True Blue Art Supply 100 Charlotte Street Asheville, NC 28801 Tel: 828-251-0028 www.artpaper.com Email: info@artpaper.com

Daniel Smith Artist Materials Seattle, WA 98134 Tel: 800-426-6740 www.danielsmith.net

Dick Blick Art Materials P.O. Box 1267 Galesburg, IL 61402-1267 Tel: 800-447-8192 www.dickblick.com Email: info@dickblick.com

Dixie Art Supplies 2612 Jefferson Hwy. New Orleans, LA 70121 Tel: 800-783-2612 www.dixieart.com

Hollander's
407 North Fifth Ave
Ann Arbor, MI 48104
Tel: 734 -741-7531
www.hollanders.com
Hollander's sells decorative papers
and bookbinding supplies, including
leathers, bookcloth, glues, binder's
board, and many tools and other
supplies, as well as offering workshops
in a wide variety of topics.

John Neal, Bookseller 1833 Spring Garden Street Greensboro, NC 27403 Tel: 800-369-9598 www.johnnealbooks.com Email: info@JohnNealBooks.com Selection of calligraphy, gilding and illuminating supplies. Source for specialty pens, nibs, inks, burnishers, gilding materials including gum arabic and gum ammoniac, and books and instructional videotapes on calligraphy and illumination.

Michaels Stores Inc. 8000 Bent Branch Irving, TX 75063 Tel: 800-MICHAELS www.michaels.com

Twinrocker Handmade Paper 100 East Third Street P.O. Box 413
Brookston, Indiana 47923
Tel: 800-757-TWIN (8946)
www.twinrocker.com
Email: twinrocker@twinrocker.com
Offers customers handmade papers and supplies to make paper. Also offers workshops and lectures on the papermaking process.

calligraphic societies and workshops

Association for the Calligraphic Arts 1223 Woodward Ave. South Bend, IN 46616 Tel: 219-233-6233 www.calligraphicarts.org Email: aca@calligraphicarts.org

The Calligraphy Society of Ottawa P.O. Box 4265 Station "E", Ottawa K1S 5B3

Society of Scribes, Ltd. P.O. Box 933
New York, NY 10150
Tel: 212-452-0139
www.societyofscribes.org
E-mail: scribesny@aol.com
Established since 1974
this organization accepts
international members.

other books on calligraphy

100 Keys to Great Calligraphy, Judy Kastin, North Light Books, 1996.

Calligraphy, Don Marsh, North Light Books, 1996.

Art of Calligraphy, David Harris, DK Publishing, 1995.

Calligraphy School, Gaynor Goffe and Anna Ravenscroft, Reader's Digest, 1994.

index

alphabet and gilded A-Z 72–4 alphabet broadsheet 33 Arkansas stone 11 automatic pens 13

backgrounds 61–2 bone folder 8 books, sewing, diagram for 55 brushes 8, 15

calendar, multilingual 56–9
capitals
flourished 28
Roman 6, 24–5
carbon paper 36
card pens 60
Carolingian minuscules 7
cartridge paper 18
Chinese ink sticks 11, 14
Christmas cards 65–7

color, gilding with 76–7 compasses 8

copperplate script 7 cutting mats 10

design 36–9 dip pens 8, 13, 19 dividers 8 drawing boards 8, 12

equipment 8–11, 60 erasers 8

flourished capitals 28 foundation hand 26–7 fountain pens 13

gum ammoniac 11, 64

gilding 64
alphabet and gilded A-Z 72–4
gilded and decorated letter 68–71
gilding with color 76–7
glassine 18, 64
glue 10, 11
Gothic 7
gouache 15
resist 62
grain, paper 17
greeting cards 44–7
grinding ink 14–15

gum arabic 11 gum sandarach 11

half uncials 6 history 6–7 Humanist minuscules 7

ink stones 11, 14–15 inks 8, 14 grinding 14–15 "insular" half uncials 6 italics 7, 28–9

Johnston, Edward 7, 22-3, 26

knives 10

layout paper 18
letterhead with monogram 41–3
letters
 analyzing letterforms 22–3
 height 21
 spacing 22
lighting 12
Lombardic versals 31

magic carpet 76–7
majuscules 6, 7
masking fluid 11, 62
masking tape 8
menu cards 48–51
minuscules 7
monogram, letterhead with 41–3
Morris, William 7
mounts, paper-covered 75
multilingual calendar 56–9

nibs 13, 19–20 sharpening 14

ox gall liquid 11

paints 10, 15
mixing 15
writing with 23
palettes 10
paper 8, 16–18
stretching 61
paper-covered mounts 75
parchment 16

paste-up layout 39 pastel backgrounds 62 patterns, words as 34–5 pen holders 13 pencils 8, 15 pens 8, 9, 13, 60 place cards 48–51 pounce 11 precissus Gothic 7 PVA glue 11

quadrata Gothic 7

Renaissance 7 reservoirs 9, 13 resists 62–3 Roman capitals 6, 24–5 rotunda Gothic 7 rulers 8 ruling pens 10, 60 ruling up 22 rustic capitals 6

San Vito, Bartolommeo 7 scissors 10 serifs 25 set squares 10 sewing books, diagram for 55 sharpening nibs 14 sizing, paper 17 spacing 22 square capitals 6, 7 stretching paper 61 string 60 strokes, basic 20–1 studio, setting up 12

T-squares 10 text and translation, combining 52–5 textured backgrounds 61 thumbnail sketches 38 tracing paper 18 transferring designs 36

uncials 6

vellum 16 versals 30–1

watercolors 15